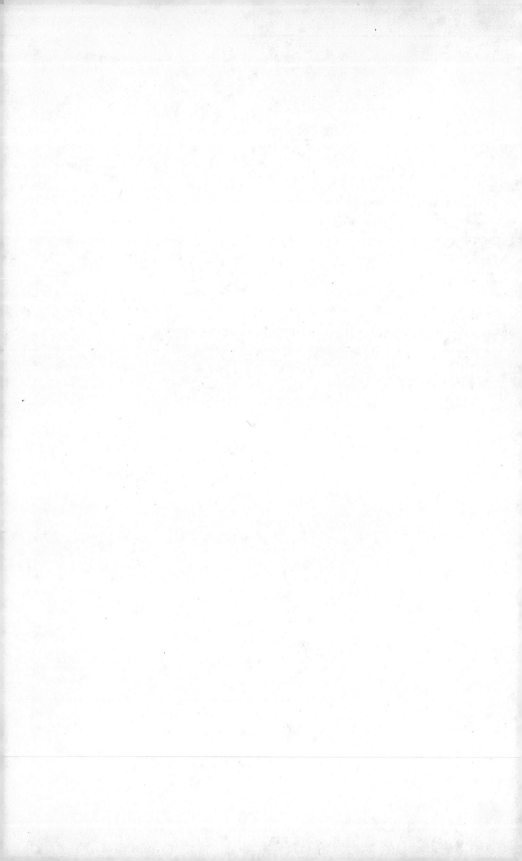

GEORGE INNESS

An American Landscape Painter

1825 - 1894

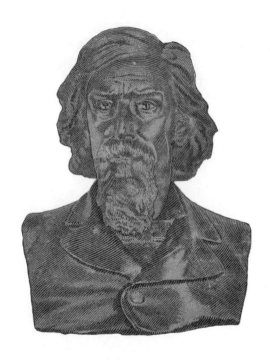

AMS PRESS

NEW YORK

AUTUMN OAKS, ca. 1875 (Cat. 25)

The Metropolitan Museum of Art

GEORGE INNESS

An American Landscape Painter

1825 - 1894

By ELIZABETH McCAUSLAND

AMERICAN ARTISTS GROUP, INC.

NEW YORK

NINETEEN HUNDRED FORTY-SIX

Library of Congress Cataloging in Publication Data

McCausland, Elizabeth, 1899–1966.
George Inness: an American landscape painter, 1825–
1894.

Reprint of the ed. published by American Artists
Group, New York.
Bibliography: p.
1. Inness, George, 1825–1894—Exhibitions.
ND237.I5M3 1978 759.13 76–42705
ISBN 0–404–15365–8

Reprinted from the edition of 1946, New York
First AMS edition published in 1978

Manufactured in the United States of America

AMS PRESS, INC.
NEW YORK, N.Y.

THE SELECTION OF PAINTINGS FOR THE
INNESS EXHIBITION AND MONOGRAPH
HAS BEEN MADE BY CORDELIA SARGENT
POND, DIRECTOR, THE GEORGE WALTER
VINCENT SMITH ART MUSEUM, AND BY
ELIZABETH McCAUSLAND. THE MONO-
GRAPH HAS BEEN WRITTEN AND EDITED
BY ELIZABETH McCAUSLAND. PUBLISHED
IN COMMEMORATION OF THE FIFTIETH
ANNIVERSARY OF THE GEORGE WALTER
VINCENT SMITH ART MUSEUM, FOUNDED
IN 1895 AS THE ART MUSEUM

EXHIBITION DATES

The George Walter Vincent Smith Art Museum, Springfield, Mass.
FEBRUARY 25 TO MARCH 24, 1946

The Brooklyn Museum, Brooklyn, New York
APRIL 5 TO MAY 12, 1946

Montclair Art Museum, Montclair, New Jersey
MAY 19 TO JUNE 23, 1946

LENDERS TO THE EXHIBITION

Addison Gallery of American Art, Andover, Massachusetts

Albright Art Gallery, Buffalo, New York

Mrs. Edward P. Alker, Great Neck, Long Island, New York

Mr. Bartlett Arkell, New York, New York

The Art Institute of Chicago, Chicago, Illinois

The Berkshire Museum, Pittsfield, Massachusetts

Mrs. David Bonner, Great Neck, Long Island, New York

The Brooklyn Museum, Brooklyn, New York

The California Palace of the Legion of Honor, San Francisco, California

Carnegie Institute, Pittsburgh, Pennsylvania

The Cleveland Museum of Art, Cleveland, Ohio

Museum of the Cranbrook Academy of Art, Bloomfield Hills, Michigan

The Detroit Institute of Arts, Detroit, Michigan

Fort Worth Art Association, Fort Worth, Texas

The George Walter Vincent Smith Art Museum, Springfield, Massachusetts

The Misses Rose, Rachel and Helen Hartley, Southampton, Long Island, New York

Dr. George G. Heye, New York, New York

M. Knoedler & Co., New York, New York

Macbeth Gallery, New York, New York

The Metropolitan Museum of Art, New York, New York

Museum of Art, Rhode Island School of Design, Providence, Rhode Island

Museum of Fine Arts, Boston, Massachusetts

Museum of Historic Art, Princeton University, Princeton, New Jersey

The National Gallery of Art, Washington, D. C.

Harry Shaw Newman Gallery, New York, New York

The New-York Historical Society, New York, New York

LENDERS—*Continued*

Colonel Albert E. Peirce, Warrenton, Virginia
Mr. Harry T. Peters, New York, New York
Philadelphia Museum of Art, Philadelphia, Pennsylvania
Phillips Memorial Gallery, Washington, D. C.
The Smith College Museum of Art, Northampton, Massachusetts
The Toledo Museum of Art, Toledo, Ohio
Wadsworth Atheneum, Hartford, Connecticut
Walker Art Center, Minneapolis, Minnesota
Worcester Art Museum, Worcester, Massachusetts
Yale University Art Gallery, New Haven, Connecticut

ACKNOWLEDGMENTS

THE INNESS EXHIBITION AND MONOGRAPH have been made possible by the generous cooperation of many institutions and individuals, and all deserve the thanks of the director and the exhibition's organizer. Especial thanks are due the American Art Research Council, which made available its Inness records, and Lloyd Goodrich, its director, whose encouragement of American art studies is a model for scholars; the Frick Art Reference Library; the Art Division of the New York Public Library; the Metropolitan Museum of Art Reference Library; the New-York Historical Society; and the Brooklyn Museum. Thanks also are due the dealers, including Robert G. McIntyre of the Macbeth Gallery; W. F. Davidson of M. Knoedler & Co.; Carmine Dalesio of the Babcock Galleries, Inc.; and Harry Shaw Newman and Miss Bartlett Cowdrey of the Harry Shaw Newman Gallery. Individual courtesies to be noted are the loan of color plates of *Autumn Oaks* from the Book-of-the-Month Club, and permission from the Montclair Art Museum to quote the autograph Inness letter to Ripley Hitchcock and to exhibit the Hartley portrait bust of Inness, both in its collections.

The exhibition and monograph will doubtless bring much new Inness material to light. It is our earnest hope that such information will be forwarded to the museum for inclusion in the forthcoming catalogue raisonné. C. S. P. AND E. McC.

CONTENTS

ix

LIST OF PLATES

LIST OF PLATES—*Continued*

FOREWORD

FIFTY years ago, Springfield, with a population of between fifty-one and fifty-two thousand, was all agog over the opening of its Art Museum, for that was the simple name it bore for close to forty years. It was an event upon which metropolitan editors expatiated, for few cities of comparable size boasted an art museum. The Metropolitan Museum, the Museum of Fine Arts, Boston, were both founded in 1870; the Philadelphia Museum, 1875; the Art Institute of Chicago, 1879. The Worcester Art Museum and Carnegie Institute came into being in 1896. Hartford, with the founding of the Wadsworth Atheneum in 1844, could claim distinction for the "first incorporated public art museum in America," reports the *American Art Annual*.

"The new building of the Springfield Art Museum," reported *Harper's Weekly,* "is very interesting in itself and in its contents. The main interest of it, however, is that it is symptomatic of the public spirit and the local pride that are at work in so many American cities to the production of like institutions . . . and that institutions which in other countries require subsidies from the government spring up spontaneously in this country, make the story of this museum of general interest and worth telling somewhat in detail."

The seeds for the growth of a lively interest in art, and the ultimate founding of this museum, were sown when Miss Belle Townsley, daughter of one of the city's leading citizens, married George Walter Vincent Smith, retired New York business man and collector. Mr. Smith transferred part of his collection to Springfield. In 1872 the *Springfield Republican* stated, "Such a collection in our midst is certainly one of the greatest benefits that could come to us, and may be the source of far more profitable advance than any increase in mere wealth or population. What

we now need is that our monied men, acting under the influence which this collection will produce, and having its excellence always in view, should take steps toward founding an art gallery which shall be free and open to the public," an editorial inspired, no doubt, by the interest of citizens in this collection.

The year 1878 was significant in the museum's history, for it saw the birth of a series of annual art exhibits, known as "Gill's Exhibitions," which continued through nearly fifty years. Mr. Smith's interest in young James D. Gill, who sold engravings and chromos, was manifested in the aid which made the series possible of attainment. Sedulously practicing and preaching the impor-tance of supporting American art, Mr. Smith went to the New York studios of his artist friends and personally selected fifty-six paintings. Thirty-six of them sold for a total of approximately $10,000, largely through the efforts of Mr. Smith. This was a phenomenal percentage of sales. Mr. Smith, again in 1879, made the trip to New York and selected seventy-nine paintings, of which number thirty-five sold.

It was the success of the first exhibition which brought Mr. Smith's decision to found an art museum. The idea was shared with his wife but kept secret from others until his plans matured.

E. L. Henry, Heade, Whitredge, and George Inness, men in whose work there is a rebirth of interest today, were included in these first two exhibits; Church, Wyant, Thomas Eakins, Homer, Harnett, and many others, appeared as the years rolled on. Spring-field citizens bought. Collectors from Worcester, Hartford, New Haven, and elsewhere, bought. Soon Gill's catalogues included the names of previous purchasers of each artist's work. These catalogues prove an interesting index to the cultural growth in Springfield.

Therefore, it was not surprising that Springfield citizens waxed enthusiastic when it was announced in 1889 that Mr. Smith had offered to present his collection to the City Library Association. He originally planned to erect his own building, but John Olm-

sted, a director of the Association, initiated a campaign and the building was provided by private subscriptions.

Walter Tallant Owen, a native son, associated with the firm of Renwick, Aspinwall and Renwick, was the designer. In 1895 the building, with some objects in place, was opened for general inspection. In April 1896, installations completed, the museum opened free of all fees. Mr. and Mrs. Smith executed the formal deed of gift of their collections in 1914. A new wing which completed the original design was added in 1923, but Mr. Smith did not live to see its completion. Until the day of his death, in his ninety-first year, he added continually to the collection. Mr. and Mrs. Smith provided for the museum an endowment which made the institution self-supporting as well as enabling it to greatly expand its activities.

This, in brief, is the history of the museum which celebrates its fiftieth anniversary by presenting a retrospective exhibition of the work of George Inness, a contemporary of its founder. But what of the man himself? The span of Mr. Smith's collecting covered more than seventy years. He was a man of strong convictions, many of whose ideas were in advance of his time. He created a large and catholic collection without great wealth. Born in 1832, he collected in a period when there were no "experts" in America. It was his firm conviction that each generation should support the native art of its own generation. This he did, buying directly from the artists. He bought with no idea of creating an art museum. Later he advocated a museum in every community and deplored the tendency toward too great a concentration of art objects in large metropolitan centers. Several communities benefited by his advice to collectors.

It was his strong belief in the importance of Inness' contribution to American art which prompted this exhibition. It is interesting that he considered his "middle" period as his greatest. The two Georges had much in common. Both were pioneers, both individualists, both were frequently misunderstood.

The rising tide of interest in our native tradition and the importance given to the rediscovery and re-evaluation of many artists who had been relegated to oblivion is a healthy sign. A study of Gill's catalogues reveals the frequency of Inness' representation in the local exhibits. In fact, a large number of the men recently "rediscovered" sold paintings here. The *Delaware Water Gap* was included in the fifteenth annual, priced at $3500, and the twenty-eighth annual adds that it was purchased by the "late Oliver H. Durrell of Cambridge." Mr. Smith had acquired his Innesses in the early sixties.

Miss McCausland's interest in the American artist and her association with the *Springfield Republican* made her the logical choice to write this monograph on George Inness, the importance of whose place in the American tradition is hereby evaluated.

CORDELIA SARGENT POND

GEORGE INNESS

GEORGE INNESS, 1825-1894

EORGE INNESS bridged the golden day of Mount and the brown decades of Eakins, spanning Jacksonian democracy and post-Civil War industrial expansion. One of the most authentic of nineteenth century American artists, he is also one of the least appreciated. While Hudson River and Rocky Mountain painters flaunted flamboyant panoramas and Church apotheosized the Andes, Inness cultivated his acre of mensurable Hackensack and Medfield meadows, of moderate New England harvests, of half-light mists seen from a Montclair studio window. To him nature was neither a stage piece nor a contour map; rather it was an intimate land, demarcated by personal boundaries of changing season, light and style. Contrast the moderation of his art with the eccentricity of his behavior, and note the measure of the American artist's dilemma: like his fellows, Inness was torn by characteristic pulls of American life, the hunger to create, the lack of a favorable social horizon for creative endeavor. Finding his horizon narrow, he chose an area commensurate with opportunity — what he called *civilized landscape,* what might be called by unfriendly critics pruned landscape. Being compelled to realize itself within limits if it were to realize itself at all, Inness' art speaks modestly of its theme. That very modesty is undoubtedly the major reason for the overlong neglect of his genuine merit.

Yet the modesty of his aim gives Inness' art its strength. Another modest painter once said: "Try to conquer those qualities which you do not possess. But above all be true to your own way of seeing. This I call conscience and sincerity." Corot might have been writing of Inness; for today Inness is acknowledged as one of America's half dozen important nineteenth century paint-

ers precisely because he was true to his own way of seeing. Others saw vast expanses of mythical landscape peopled with misty wraiths rising from impossible mountain peaks; but Inness looked at the nearby acre of his own backyard. It was a fragment of nature he painted, made meaningful by being of dimensions which could be seen. Inness' art is not necessarily an art of understatement; but it is an art of non-self-assertion, and fortunately the aggressiveness engendered by adversities of the artist's lot did not tinge his work. Like Corot, Inness painted a serene world — a world unharried by inner tempests, and a world in which outer storms took on a stable air.

If naturalism is the background for Inness, the term must be read to mean more than physical representation of natural appearances. Nature surely meant more to Inness than a congeries of objects, items, materials, textures and surfaces. For him it must have meant the total natural world in which man lives, sees, feels, senses, experiences, thinks, moves, acts, suffers and dies — as well as external "facts" of changing light and foliage, field and meadow and gentle hill, winding curves of Hudson and Delaware, an occasional farmhouse or old stone fence, or a human figure placidly subordinate to the land. A spiritual or moral content of human experience is plainly embodied in Inness' view of nature and set forth in his painting. To describe this content the adjective "serene" may be repeated; for serenity is dominant in his art. Where Mount suffused his canvases with the morning glow of American life and Homer poured a stoical fortitude into his late masterpieces, Inness filled his with a confident gentleness. The land will endure, his paintings say, the coming storm will pass, the harvest will ripen. Nature stands and will suffice, his work proclaims.

Though the still small voice does not win easy notice among pyrotechnics, today we enjoy Inness' small paintings or unfinished works as much as his larger canvases, or perhaps more. In his day, however, he was forced to compete with pictures painted by the square yard. Would he have suffered less personal stress

if the age had measured merit by standards other than quantitative? Nonetheless, Inness preserved his calm, as the large *Peace and Plenty* proves; and in smaller paintings his serenity glows intensely; for, if fashion forced him to paint large canvases, he was wise enough to avoid spurious "bigness" of subject and style. In fact, only conscience and sincerity could have kept him true to his own way of seeing in a period when esthetic diversions and distractions were many.

What kind of a world did Inness live in? And what were the diversions and distractions he resisted to pursue his own vision?

Born in 1825, Inness was of the generation of the Hudson River School. Inheriting with his period the naturalistic tradition of Cole and Durand, he was self-taught except for a month's study with Régis Gignoux. When he made his first trip to Italy in 1847, he had been painting for over five years and exhibiting since 1844 at the National Academy of Design and the American Art Union, and his talents had attracted a patron in Ogden Haggerty who sent him abroad. Inness came back from Italy with a broader brushstroke and some Italian subject matter; but not till the 1860's did he assimilate classical landscape. By that time he had made a mature statement in *Hackensack Meadows*, 1859 (pl. 9), *On The Delaware River*, ca. 1861 (pl. 13), and *Peace and Plenty*, 1865. He knew of European art fashions but avoided entanglement. As early as 1850 he considered Théodore Rousseau "metalic"; and though later he admired the Barbizon painters, he did not model himself on other artists. Parallels between his painting and that of Corot, Turner, and the early impressionists are due rather to the fact that all played the sedulous scholar to the same master, nature. His independence of influences, like his failure to found a school, is to be marked in relating his growth to the forces of American life.

Unlike the Hudson River School, grounded in a meticulous rendering of natural detail, Inness' was an art of understatement. His earliest known works — *Surveying*, 1846 (pl. 1), *Landscape*,

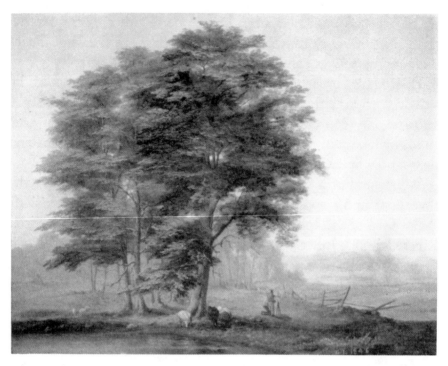

Plate 1 SURVEYING, 1846 (Cat. 1) *M. Knoedler & Co.*

1848 (pl. 2), *The Old Mill,* 1849 (pl. 3), and *Summer,* 1850 (pl. 4) — reveal the hand of a lingering naturalism; but on the whole Inness did not dot the *i*'s and cross the *t*'s of nature. The early *Lackawanna Valley* (pl. 5), commissioned in 1855, passing beyond the formative stage, makes a completely personal statement of the painter's theme. Though the artist himself thought of it as a potboiler, this is to deny the painting's genuine expressiveness and freshness. By the time Inness was thirtyfive, an age at which many artists are still in search of their souls, he had shaken off precedent and painted the 1858 *Italian Landscape* (pl. 8) and the 1859 *Hackensack Meadows* (pl. 9), using a broad, free touch anticipatory of his late impressionism. Cool and unelaborate, his art might well have been lost in the contemporary welter of canvases painted by the square yard and studded with properties of the romantic "machine." No ruined antiquities,

[4]

oceans of blood, allegorical wraiths rising from topless mountain peaks, cluttered his studio; and less dramaturgical spectacles than those of Cole's *The Course of Empire* satisfied his aspiration. In his painting Inness revealed a bent for the quiet and tranquil, curious in a man of stormy temper. Contrasted with romanticism's baroque libretti, his program is direct, modest, strong; and his struggle to express the simple truth of nature as he saw it gives his painting an especial intensity.

Recently Inness' reputation has undergone rehabilitation, along with that of other nineteenth century American artists. In 1922, $60,000 was paid for his *Spirit of Autumn* — a new "high" for American art. In the main, however, his genuine achievement has been underrated in a period dedicated to formalism and intellectualism. Only now, on the crest of the rediscovery of America, has his painting come back into favor; and there are art historians wedded to the "great tradition of western art" who deny Inness' lasting significance. His economic life parallels his professional recognition. Material success came late, after 1875, when Thomas B. Clarke became his protector. Nevertheless at his death in 1894 he left unsold works which brought in over $100,000 at the 1895 executors' sale. This was not as vast a sum as Bierstadt's two-million-dollar estate, but considerable. During the 1900's Inness' vogue continued, and his prices rose; but his prestige rating declined as modern art captured America after the 1913 Armory Show and World War I. In the past twenty years, he has made a remarkable comeback in market and critical values. The centenary of his birth, celebrated by the 1925 exhibitions at the Albright Art Gallery and at the Macbeth Gallery, launched his revival. The rediscovery of America, which began in the 1920's, accelerated during the 1930's and culminated in the years of war devotion to national ideals. This process has completed the historic reversal of Inness' reputation, as it has done for many artists not long ago deemed stuffy and "old hat."

The process of rehabilitation from 1925 to 1945 can be charted

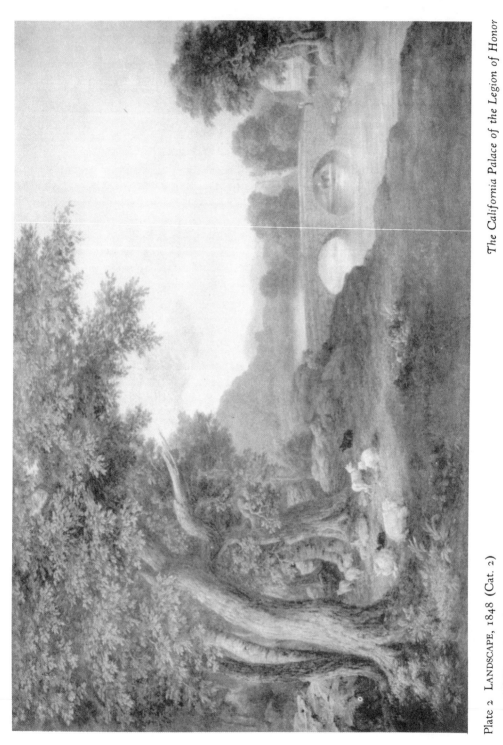

Plate 2 LANDSCAPE, 1848 (Cat. 2)

The California Palace of the Legion of Honor

Plate 3 THE OLD MILL, 1849 (Cat. 3)

in a chronology which applies not alone to Inness. The rapid rebirth of the native tradition in recent years is one more instance of the capriciousness of vogue in matters of taste; yet it has served a good end in bringing our forgotten masters to notice again. The record reads as follows — 1925: centennial exhibitions. 1927: Hartley sale. 1930: Newark Museum, "Development of American Painting, 1700-1900." 1932: Museum of Modern Art, "American Painting and Sculpture." 1933: Chicago, "Century of Progress." 1935: Montclair Art Museum, Inness 110th anniversary exhibition. 1936: Cleveland Art Museum, "American Painting from 1860 Till Today"; Virginia Museum of Fine Arts, "Main Currents in the Development of American Painting"; San Francisco Museum of Art, "Survey of Landscape Painting." 1938: Whitney Museum of American Art, "A Century of American Landscape Painting, 1800-1900"; also at the Springfield Museum of Fine Arts in 1938; and at Carnegie Institute in 1939. 1939: San Francisco Golden Gate Exposition, "Historical American Paintings." 1940: New York World's Fair, "American and European Paintings, 1500-1900"; Carnegie Institute, "A Survey of American Painting"; Century Association, "Fifty Years of American Painting, Landscape and Genre, 1825-1875." 1941: Santa Barbara Museum of Art, "Painting Today and Yesterday in the United States." 1942: Whitney Museum of American Art, "A History of American Watercolor Painting." 1943: Museum of Modern Art, "Romantic Painting in America." 1944-45: the Detroit Institute of Arts, "The World of the Romantic Artist." 1945: the Art Institute of Chicago and the Whitney Museum of American Art, "The Hudson River School and the Early American Landscape Tradition"; the Walker Art Center, the Detroit Institute of Arts, and the Brooklyn Museum, "American Watercolor and Winslow Homer." Add to this rising tide of American art recent important one-man exhibitions of nineteenth-century artists — William Sidney Mount, John Quidor, and Eastman Johnson, the Brooklyn Museum; Eakins, and Homer, the Whitney

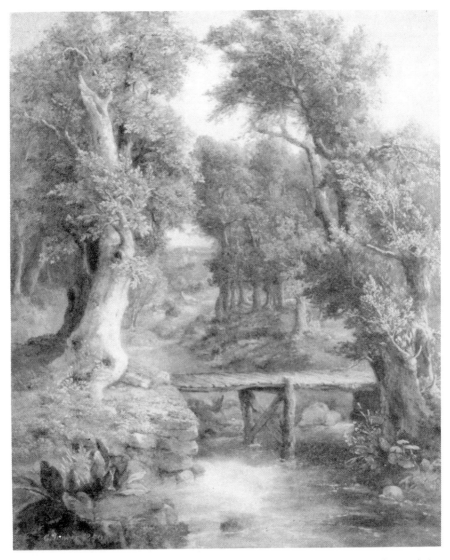

Plate 4 SUMMER, 1850 (Cat. 4) *Museum of the Cranbrook Academy of Art*

Museum; Mount, 1945, the Metropolitan Museum of Art — and it is plain that the time is ripe for Inness' reëmergence on the American scene.

Today he takes his place as a master of nineteenth century American landscape. This exhibition and this monograph are one

proof of his return to vogue. The more reason why his creative achievement should be revalued; for there is danger that redis-covery of the American tradition be accompanied by perilous *Buy American* trends. What is needed is objective appraisal of George Inness' contribution to American art.

Basic reëvaluation must rely on the evidence of his work. With Inness, as with the majority of American artists, lack of docu-ments is a grave handicap. Standard dictionaries of biography and the semi-official "Life," published by George Inness, Jr., twenty-three years after his father's death, repeat stereotyped anecdotes; and though bibliographical references are profuse, they deal chiefly with exhibition, sale and criticism. Perhaps his epilepsy caused Inness' family to erect more than usually thorny shelters about his fame. A few letters survive, those quoted by George Inness, Jr., and the autograph letter to Ripley Hitchcock, now in the collec-tions of the Montclair Art Museum, hereinafter quoted at length. Inness' own report is no more reliable than that of his biographers, and his vague, metaphysical remarks on art are not as interesting as his practical observations. Surely it is a phenomenon of Amer-ican civilization that American artists came late to intellectual and esthetic interests. They did very well if correspondence dealt with building a house or a recalcitrant patron's haggling over a previously agreed-on price. But where are the nineteenth century American painters who concerned themselves with voicing deep, underlying creative problems, as did Van Gogh in his letters to Émile Bernard? Perhaps native art sailed under the banner of pragmatism and empiricism as much as under the banner of natur-alism. Or are these twin aspects of one reality?

Born on a farm two miles from Newburgh, New York, on May 1, 1825, George Inness grew up a New Yorker and a sub-urbanite — a combination which controlled his life. That year his family removed to New York — according to myth, in a sail-ing sloop down the Hudson — and four years later to Newark, where young George grew up. There he attended the local acad-

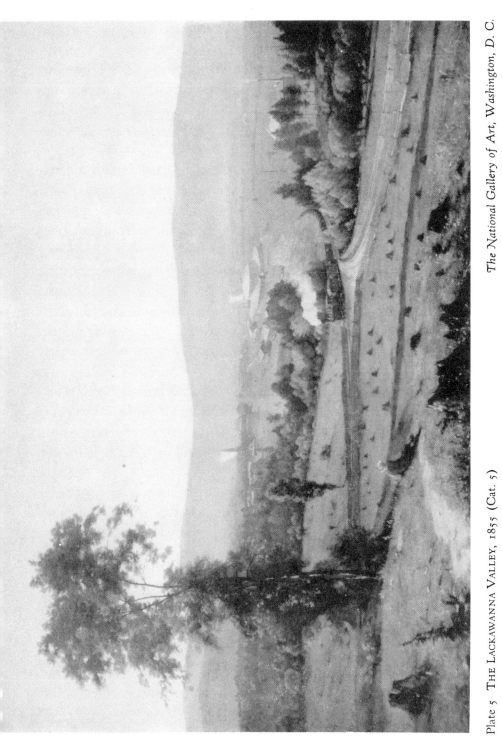

Plate 5 THE LACKAWANNA VALLEY, 1855 (Cat. 5)

The National Gallery of Art, Washington, D. C.

emy and at fourteen was put by his father to tend a small grocery store. He had a little teaching from a Newark drawing-master named Barker, served a year's apprenticeship with the New York map-engravers, Sherman and Smith, and in 1846 had his only formal art instruction, a month's study with Régis Gignoux, a pupil of Delaroche. It had been Delaroche who exclaimed — after seeing Daguerre's premiere demonstration of photography before the French Academy of Sciences in 1839 — "Painting is dead from this day." Something of Gignoux's master's implied love of qualities loosely and erroneously called *photographic* may have passed into the student's brush. When Gignoux came to the United States, he allied himself with the Hudson River School painters, and some of his tightly painted canvases are equal to their best. His influence was handed down to a number of American painters, including the genre painter, Edward Lamson Henry. Thus the school's tight hard rendering of textures, surfaces and minutiae was transmitted to the younger generation of American artists.

The Hudson River image is fresh in memory, thanks to the fine exhibition organized last year by the Art Institute of Chicago and also shown at the Whitney Museum of American Art. The recent exhibition of European and American landscapes at the Brooklyn Museum reënforced this image, so we have visual points of reference for Inness. The painters of the school are generally well represented in American museums, belonging as they do to that stuffy and "old hat" group once fashionable and now coming back into favor. For this exhibition the George Walter Vincent Smith Art Museum has put on view a supplementary display of works which serve to place Inness in his period. Beginning with Cole, prophet of grandiose romanticism, the tradition developed into the typical American extraverted representation of nature. Inness' masters were Cole, and Durand (that practitioner of literal naturalism); and he took from both what he could use of their qualities. Cole's flamboyant version of the American land was toned down, while Durand's exact transcriptions of foli-

age, soil and rocks were also moderated, becoming less rigid and literal. The panoramism Church delighted in never seduced Inness; and in fact he abhorred the view as such, even though his own first art work was grounded in his map-engraving training. When Inness sought to rival Cole's literary *Expulsion from the Garden of Eden,* he produced a machine of his own, *The Valley of the Shadow of Death,* elsewhere mentioned (p. 31). Later, the second generation of the Hudson River School abated naturalism somewhat in favor of Church's acre-large landscapes or Bierstadt's allegories. But Inness stood aside from formal allegiance.

In essence his Hudson River legacy is an historical consequence of the culture into which he was born. He knew no other tradition or source of inspiration. Trumble tells of a conversation with Inness in which he describes his first contact with "art." He had seen engravings after old masters in the window of a print shop, and for the first time he saw nature "rendered grand." Inness

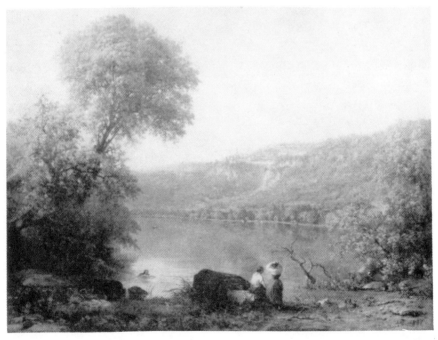

Plate 5a LAKE COMO (?), 1857 (Cat. 5a) *Yale University Art Gallery*

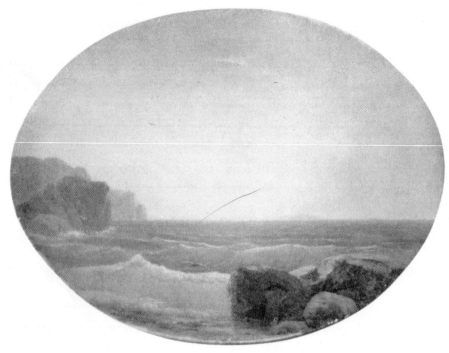

Plate 6 MARINE, 1857 (Cat. 6) Macbeth Gallery

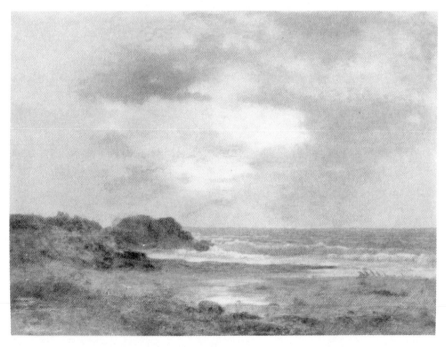

Plate 7 COAST SCENE, ca. 1857 (Cat. 7) The Metropolitan Museum of Art

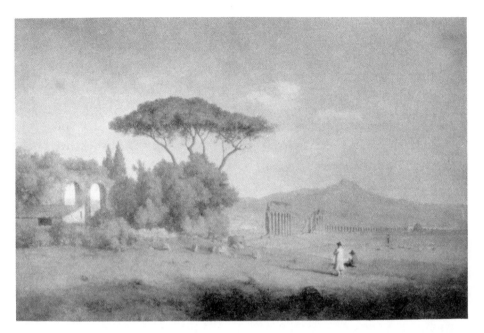

Plate 8 ITALIAN LANDSCAPE, 1858 (Cat. 8) *Lent Anonymously*

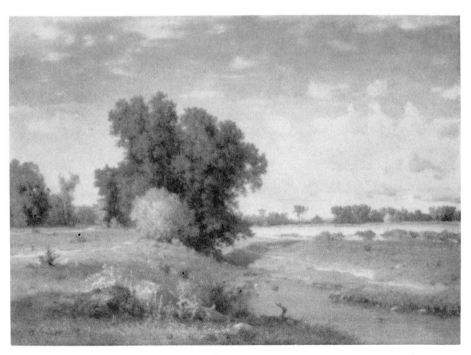

Plate 9 HACKENSACK MEADOWS, SUNSET, 1859 (Cat. 9) *New-York Historical Society*

found something of these same qualities in Cole and Durand, he continues, saying, "There was a lofty striving in Cole, . . . There was in Durand a more intimate feeling of nature." In his forma-tive period, no doubt his map-engraving training was a major factor. The 1859 canvas, *Landscape (Delaware Water Gap)* (pl. 10), shows the inheritance of the view painter. Oddly enough, though the 1860 Currier & Ives print, *View on the Delaware* (pl. 10-a), has less of the topographical spirit, it is not so interesting from an esthetic point of view. Besides the fact that it has been "doctored up" in the Currier & Ives studios, with a genre note added, it has lost the sweep of the painting. Probably Inness learned most, however, from nature itself. Titles shown at the National Academy and the Art Union from 1844 on refer to place names around Newark and on the Schuylkill, and many of his student works were painted at the home of his brother James, a schoolmaster in Pottsville, Penn. Pennsylvania landscape was a subject he frequently came back to, painting the Delaware Water Gap as late as 1867 in *Harvest Scene* (pl. 19). His first effort is *The Mill,* known only in reproduction and recorded as having been painted when Inness was sixteen. In 1843 he had a studio in New York and boarded at the old Astor House. His first works — aside from the "lost" *Mill* — are said to date from this year. The earliest we have located are *Surveying,* 1846 (pl. 1), included in the exhibition, and *Woodland Scene* of the same date, not in the exhibition. From 1844 through 1846, National Acad-emy and Art Union catalogs list thirteen titles by Inness, whose name was variously spelled with one *s* and two.

Inness had been married early (though biographical sources are vague as to the date) to Delia Miller, who died soon after their marriage. By 1846 he was located in New York, the National Academy catalog listing his address as the corner of Nineteenth Street and Ninth Avenue. At this time, "to receive $25 for a picture was a triumph for him." According to Inness' letter to Ripley Hitchcock, written years after in 1884, it was this

[16]

year that he studied with Gignoux. He wrote, in part: "When about twenty I had a month with Gignoux my health not permitting me to take advantage of study at the Academy in the evenings. This was all the instruction I ever rec'd from *any* artist." A year later he made his first trip to Europe, going to England and then to Italy, where he remained in Rome for more than a year. Already, if his later recollections are accurate, he was establishing himself as an artist; for he wrote Hitchcock: "At twenty-two I was looked upon as a promising Youth and was able to sell to the Art Union as high as $250.00 and I believe in one instance $350.00. Some of my studies were very elabourate" [*sic*].

Information about Inness' first visit to Italy is scanty. The 1848 *Landscape* (pl. 2) indicates that by this date he had come in contact with classical landscape, though Lorrain and Poussin did not at once substantially modify his Hudson River tight, literal transcripts of nature. Like his American predecessors, he continued to paint each leaf and stone and fold of bark; but in this early Italian subject he coupled grandiose Hudson River literalism with classical apparatus, surely an effect of life and travel in Italy. What was the "lost" painting like, *Diana Surprised by Acteon*? No. 159 in the 1848 Academy catalog, it is listed as having been purchased by Ogden Haggerty, Inness' dry-goods auctioneer Medici. Classical influences may be read also in *The Old Mill*, 1849 (pl. 3), probably No. 128 exhibited at the Art Union that year. The Italian phase persisted into 1850, when besides *Summer* (pl. 4), the pastoral Hudson River example herein included, Inness painted two known large works, *March of the Crusaders*, 36¼ by 49¼ inches, and *Gloomy Days of '76*, 46¾ by 65¼ inches — neither of which unfortunately is available for exhibition. *March of the Crusaders* is one of his few known paintings on a literary theme; and *Gloomy Days of '76* is noteworthy as being probably his only canvas on an American historical subject. Meanwhile he was veering away from the literary and historical program of romantic painting, to find his own bent, the simple and modest view of nature.

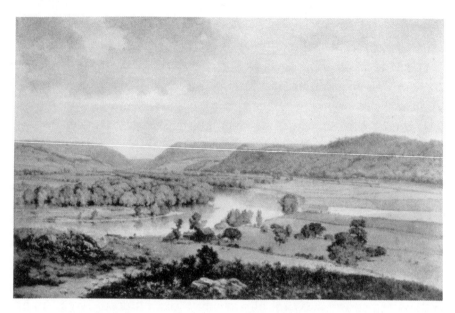

Plate 10 LANDSCAPE (DELAWARE WATER GAP), 1859 (Cat. 10) *Montclair Art Museum*

Luckily he was encouraged to develop his own way of seeing by his then benefactor, Ogden Haggerty. In 1850 Inness married his second wife, Elizabeth Hart, and went abroad again. Writing Ripley Hitchcock, he chronicles this period as follows: "In 1850 I was married to my present wife. Mr. Ogden Haggerty who had already greatly assisted me allowed me a certain sum for study in Europe. I was then twenty-five. Spent about fifteen months in Italy returning through Paris and seeing the Salon. Rousseau was just beginning to make a noise. A great many people were crowding about a little picture of his which seemed to me rather metalic. Our traditions were English, and French art — particularly landscape, had made but little impression upon us. Several years before I went to Europe however I had begun to see that elabourateness [sic] in detail did not gain me meaning. A part carefully finished, my forces were exhausted. I could not sustain it everywhere and produce the sense of spaces and distances and with them that subjective mystery of nature with which wherever I went I was filled." Few works have survived

from the following three years. He did not exhibit at the Academy in 1851, though he did in 1852. In 1853 the titles listed show Italian and American subjects — *Nook in Catskill Clove, View of Genzano, A Bit of the Roman Aqueduct,* and *Italian Composition,* none of which has turned up. Perhaps this exhibition and the publication of this monograph will bring them to light and help fill in the record.

In 1853, at the age of 28, Inness was elected an associate of the National Academy. Homer was elected A. N. A. at 28, E. L. Henry at 26, and Mount at 24. But Homer won the coveted N. A. at 29, Henry at 28, and Mount at 25. With Inness, elevation to N. A. had to wait till 1868, when he was 43. The reason why there should have been a fifteen years lag between the two honors does not appear in the biographies. It seems odd. Inness exhibited regularly in the Academy exhibitions and won as much *succes d'estime* as most; and as early as 1864 that discerning critic and collector, James Jackson Jarves, wrote of his work at length

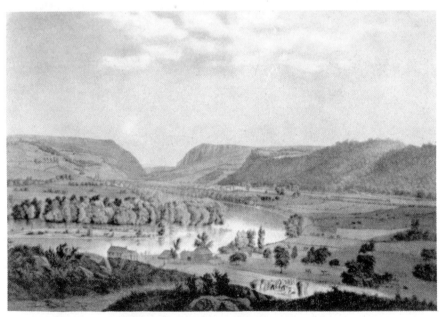

Plate 10*a* VIEW ON THE DELAWARE, 1860 (Cat. 10*a*)
Harry Shaw Newman, The Old Print Shop

Plate 11 CLEARING UP, 1860 (Cat. 11)

The George Walter Vincent Smith Art Museum

in *The Art-Idea,* saying in part that "He can be as sensitive as he is powerful in his rendering of nature's phenomena. The aërial distances and perspective of his best moods are subtile and delicate, like nature herself. We can breathe in his atmosphere, and travel far and wide in his landscape." Jarves added "that unlike the generality of our landscape art, his does not hint a picture so much as a living realization of the affluence of nature. Inness gives with equal facility the drowsy heat, hot shimmer, and languid quiet of a summer's noon, or the storm-weighed atmosphere, its dark masses of vapor, and the wild gathering of thunder-clouds, with their solemn hush before the tempest breaks. He uses sunlight sparingly, but it glows on his canvas, and turns darkness into hope and joy. . . . The spirit of his landscapes alone is American."

In 1854 Inness visited Europe again, going to Paris this time. On his return to the United States he went to Brooklyn to live. He did not exhibit at the National Academy this year. The following year, 1855, stands out as a red-letter year in his artistic development; for it saw the production of that ingratiating "sport," *The Lackawanna Valley,* 1855 (pl. 5). Formerly known as *The First Roundhouse of the D. L. and W. R. R. at Scranton,* this canvas is as minutely documented as any of Inness' paintings. The family story has been set down at length in "Life" and in the 1927 Hartley sale catalog and is repeated here, because it suggests that the artist is no more the best judge of his accomplishment than the patron! The Hartley sale catalog reprints the *New York Herald's* August 12, 1894, obituary notice: "This painting was originally commissioned by the first president of the D. L. and W. R. R. Inness journeyed by stage to Scranton to make a preliminary sketch, lost his bag, and had to write his wife for funds. He returned and executed the present canvas; this was at first declared unsatisfactory by the railroad committee, who insisted not only that he show all four trains of the road but that the letters D. L. and W. appear on a locomotive. Inness demurred, but being in need of money was persuaded by his wife to make the necessary additions.

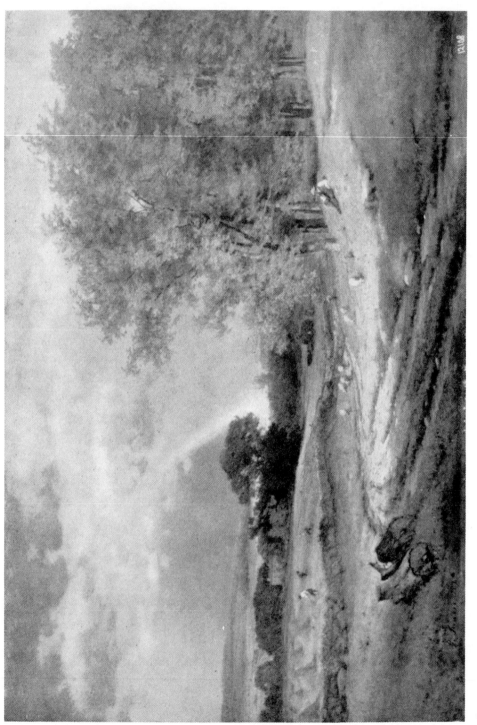

Bartlett Arkell

Plate 12 PASSING SHOWER, 1860 (Cat. 12)

Plate 13 ON THE DELAWARE, ca. 1861 (Cat. 13)

The sequel may be quoted in Inness' own words: 'Here, for instance, is a picture I made of Scranton, Pa., done for the Delaware and Lackawanna Railroad, when they built the road. They paid me $75 for it. Two years ago, when I was in Mexico City, I picked it up in an old curiosity shop. You see I had to show the double tracks and the round house, whether they were in perspective or not. But there is considerable power of painting in it, and the distance is excellent.' " The catalog entry describes the four trains as follows: "Rounding a bend is an early locomotive pulling a load of freight cars; in the distance are the company's remaining three trains." The painting brought $2700 in 1927 — a 3600 per cent rise over the $75 paid Inness in 1855.

In 1856 Inness was listed at 627 Broadway, in the National Academy catalog, and credited with exhibiting two portraits, both of women, Nos. 26 and 134. These "sports" of another genus have not come to light. The following year brought forth *Marine* (pl. 6), one of the few known seascapes from Inness' brush. This painting seems to be a throwback to a more gauchely and tightly rendered style, such as may be seen in extant photographs of the "lost" 1853 *View of Genzano*. Scalloped waves, as rigid as if cut out of wood, echo Hudson River School mannerisms, notably Kensett's Newport views of the 1850's, in which literalism creates a highly decorative effect. The same quality may be noted in another mid-nineteenth century landscape painter, the lately resurrected Martin Johnson Heade, who painted fantastic landscapes with more flair but no less tight a brushstroke. Legend says Inness painted no marines, or only one, or a few. This is inexact. Several marines are known, in collections which do not lend. Inness painted at Anzio, in Normandy (echoing Courbet's *Etretat)*, in Cornwall, and perhaps along the Jersey coast. No doubt the sea was not his metier as it was Homer's; or perhaps American patrons of his day demanded peaceful, smiling, sleeping valleys at harvesttime, with placid cows munching? Nevertheless, *Coast Scene, ca.* 1857 (pl. 7), which seems to belong to his early Italian period

Plate 14 SHADES OF EVENING, 1863 (Cat. 14)

The George Walter Vincent Smith Art Museum

Plate 15 LANDSCAPE, 1864 (Cat. 15)

Plate 16 LEEDS IN THE CATSKILLS, 1865 (Cat. 16)

rather than to Normandy or Cornwall, is a good painting, though overcast with varnish. The 1857 painting, *Lake Como* (pl. 5a), attributed to Inness on what seem to be very good probabilities, echoes the rendering style of this period, particularly the *View of Genzano*.

In a study of Inness' esthetic evolution, what may be called his hop-skip-and-jump tempo is strikingly evident. The loose and facile mood of *Lackawanna Valley* is ahead of its date of painting, 1855; in it Inness has shaken off the visual bonds of the Hudson River School and found a free, flowing language for the high noon of American innocence. Yet the 1857 *Marine* returns to the tentative, exploratory mood of his formative period, in which he gropes for what he wants to say. The sureness of grasp and maturity of feeling which make *Lackawanna Valley* so happy an American document are also found in the 1858 *Italian Landscape* (pl. 8), in which traditional campagna and aqueduct are spontaneously presented. By 1859 he had achieved emancipation from the meticulous rendering of surfaces, to judge from *Hackensack Meadows* (pl. 9). Yet the generalization is belied by the atypical 1859 *Landscape (Delaware Water Gap)* (pl. 10), in which Inness harks back to map-engraving tendencies. The quality of topography is not strained in this canvas; from a stylistic point it is, however, a reversion. Inness' concentration on rendering surface textures persists as late as 1860 and 1863, in the small, fine canvases purchased contemporaneously from the artist's studio by the founder of this museum, George Walter Vincent Smith — *Clearing Up* (pl. 11) and *Shades of Evening* (pl. 14). In these, highlights on trees, roughness of bark, and other textural surfaces are minutely depicted. Yet at the same time Inness was painting the large 1860 *Passing Shower* (pl. 12), in which he fused American subject matter and Italian style. This synthesis was to perfect itself in his canvases of the Delaware Water Gap, including the second one in our exhibition, *On the Delaware, ca. 1861* (pl. 13). The unevenness of his stylistic evolution makes

the dating of his paintings by internal evidence somewhat per-plexing. It is no explanation to say that all artists show lags and spurts in their growth. With Inness some special factor seems to have been at work. Was this his ill health?

Inness moved to Medfield, Massachusetts, in 1859. His best known canvas, the panoramic *Peace and Plenty*, 1865, dates from his Medfield period. It is a painting pervaded by the spirit of release after the drum-taps of the Civil War had ended. Inness was a passionate abolitionist and partisan of the Union cause, who raised a volunteer militia company, only to collapse physically as he was about to march off for the front with his recruits. *Peace and Plenty* has become a cliche of American art history, its 77⅝ by 112⅜ inches having been reproduced so often at postcard size that it is usually thought of as an example of calendar art. Yet the painting possesses intrinsic and lyrical appeal at a level of

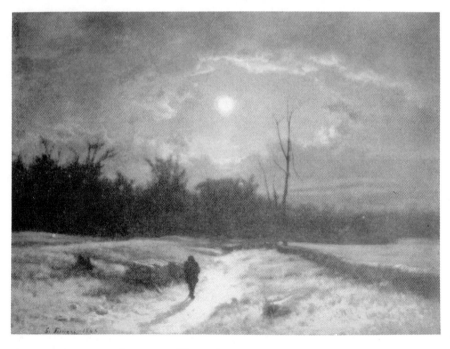

Plate 17 CHRISTMAS EVE, 1866 (Cat. 17) *M. Knoedler & Co.*

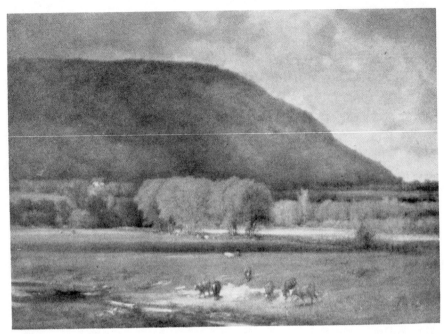

Plate 18 HUDSON RIVER VALLEY, 1867 (Cat. 18) *The Detroit Institute of Arts*

emotion, though less ecstatic, not unlike that of Whitman when
he wrote:

> "Give me the splendid silent sun, with all his beams full-dazzling;
> Give me juicy autumnal fruit, ripe and red from the orchard;
> Give me a field where the unmow'd grass grows;
> Give me an arbor, give me the trellis'd grape;
> Give me fresh corn and wheat — give me serene-moving animals,
> teaching content . . ."

Considering Inness' production during his years at Medfield, one
is moved to a mild wonder about the relation of our artists to the
Civil War, a chapter of American art history still to be written.
A few left records of frontline military life, such as Homer's
reportage for *Harper's*, Henry's as yet unpublished sketches of the
Potomac campaign, and fugitive canvases from Bierstadt, Blythe,
and the rest. But on the whole American artists of the time seem
to have absented themselves from emotional and civic identifica-
tion with the vast issues rending the age. In this they were unlike

that crusty man of letters, Oliver Wendell Holmes, who wrote in 1859 with a premonition of the conflict to come of how photography might chronicle "the very instant of the shock of contact of the mighty armies that even now are gathering." In Inness, the abstention is understandable. If he was not physically able to sustain emotional pressure, he naturally turned to the idyllic — as in the 1864 *Landscape* (pl. 15), complete with New England salt box roof and stone walls, or in the 1865 *Leeds in the Catskills* (pl. 16), in which the artist sketches away peacefully. The familiar, homely theme of another "sport" like the 1866 *Christmas Eve* (pl. 17) suggests his need for calm. Painted in a silvery gray monochrome, it is one of the most tranquil of his canvases in color, though possibly somewhat sentimental and literary in theme.

After the Civil War, Inness moved back to his boyhood haunts, going to live at Eagleswood, N. J., near Perth Amboy — a move he was persuaded to make by Marcus Spring. Spring, a patron of William Page, a one-time president of the National Academy, became interested in Inness' painting and later acted as his agent. He is said to have taken *Peace and Plenty* in part payment for a house he built Inness in Eagleswood. It was Page who interested Inness in Swedenborgianism. This religious faith, with his belief in abolitionism and the single tax, comprised Inness' intellectual interests outside art. During this period, he had some pupils, including Louis C. Tiffany and Carleton Wiggins. About this time, too, he was commissioned by Fletcher Harper, Chauncey Depew, Clarke Bell and others, to paint a series of paintings, the artist selecting *Pilgrim's Progress* as a scenario. At least one has survived, *The Valley of the Shadow of Death,* a canvas 48 by 73 inches, now in the Vassar College Art Gallery. In 1892, a wood engraving of this painting was published in *Harper's,* with a poem by Whitman written by request to accompany the picture. Entitled "Death's Valley," the poem reads as follows:

Nay, do not dream, designer dark,
Thou hast portray'd or hit thy theme entire:

I, hoverer of late by this dark valley, by its confines having glimpses
 of it,
Here enter lists with thee, claiming my right to make a symbol too.

For I have seen many wounded soldiers die,
After dread suffering — have seen their lives pass off with smiles;
And I have watch'd the death-hours of the old; and seen the infant die;
The rich, with all his nurses and his doctors;
And then the poor, in meagerness and poverty;
And I myself for long, O Death, have breathed my every breath
Amid the nearness and the silent thought of thee.

And out of these and thee,
I make a scene, a song, brief (not fear of thee,
Nor gloom's ravines, nor bleak, nor dark — for I do not fear thee,
Nor celebrate the struggle or contortion, or hard-tied knot),
Of the broad blessed light and perfect air, with meadows, rippling
 tides, and trees and flowers and grass,
And the low hum of living breeze — and in the midst God's beautiful
 eternal right hand,
Thee, holiest minister of Heaven — thee, envoy, usherer, guide at
 last of all,
Rich, florid, loosener of the stricture-knot call'd life,
Sweet, peaceful, welcome Death.

Though the magazine feature does not state whether this was a
recent production of the "good gray poet," it was published in
the year of Whitman's death, 1892, twenty-five years after Inness
painted the canvas. The collaboration is chiefly interesting as
being one of the rather rare instances of interchange between
artists in different mediums.

Inness now entered a highly productive period. His Medfield
phase, ushered in by *Peace and Plenty* in 1865, had a convenient
terminus in 1875, with another Medfield subject, *Evening at Med-
field,* also not in the exhibition. Both are classics of American
painting, and are frequently on view at the Metropolitan Museum
of Art. They may serve therefore to delimit his period of cres-
cent personal classicism. The lessons of his Italian years, early
and late, made themselves evident. It is noteworthy that some
of Inness' best "Italian" canvases predate his fourth trip abroad,

that of 1870-74. The 1867 *Harvest Scene in the Delaware Valley* (pl. 19), painted before this trip, is one of the finest expressions of what we have called Inness' personal classicism. Perhaps we have been too prone to attribute the highly formal and architectural manner of his so-called "middle" period to the effects of the years spent in Italy and France during the early seventies. It seems reasonable that the fertilizing influence of his first trips of 1847, 1850-51, and 1854 had taken root and flowered though slowly. Another canvas of 1867, *Hudson River Valley* (pl. 18), almost wholly evades classical inspiration, however. This pair of paintings demonstrates the previously made point in regard to Inness' unevenness. Such contrasts render difficult categorization of his canvases into periods; and one must expect to weight such oscillations in his quality. By 1869, the classical mood was strongly in evidence. His fine *Lake Albano, Italy* (pl. 20) indicates how he recollected in tranquillity the emotions of his first visits to Italy, while the smaller 1869 *Near Eagleswood, N. J.* (pl. 22), on an American theme, suggests that the classical view of nature depends not on subject matter but on a way of seeing. Nevertheless during this stay in Italy, Inness' bent toward classicism developed to an even higher level, as the large *Rainbow over Perugia, 1875* (pl. 24), shows.

All in all, the four-year sojourn of the Inness family (father, mother and children) brought a rich harvest. According to his son, the summers of 1870 and 1871 were spent in Perugia, the summer of 1872 in Albano, and the summer of 1873 in Pieve de Cadore, the latter documented so far only in a "lost" water color. The next year the Innesses went to France, where Inness painted at Etretat. Canvases of this period to be noted include the 1871 *Tivoli* (pl. 21), the 1873 *Olives* (pl. 23), and the *Rainbow,* in which his expression moves to an ever more plastic level. This was truly a time of flowering for Inness. Alban hills, Roman aqueduct, campagna, Appian Way, St. Peter's, Tivoli, the Tiber below Perugia, Lake Nemi, Venice, the port of Anzio, are but

Plate 19 Harvest Scene in the Delaware Valley, 1867 (Cat. 19)

Plate 20 LAKE ALBANO, ITALY, 1869 (Cat. 20)

Phillips Memorial Gallery,

a few of the subjects he painted. In some respects he anticipated the formal elegance of a later American painter, Arthur B. Davies, achieving in *The Monk*, 1873, and *The Sacred Wood, ca.* 1873-74, an uncharacteristic but striking flat decorative design. Such departures from a norm have significance; for they suggest that devotion to natural appearances will lead an artist beyond his own convention. In 1874 Inness painted marines at Etretat, even imitating Courbet, one of the few cases in which he seems consciously to have been influenced by another painter. Years later, in the letter of 1884 in which he set forth his views on impressionism, Inness found a good word for the painter he had copied. Amid observations, mostly negative, he wrote of "realists whose power is in a strong poetic sense as with Corbet" [*sic*]. No doubt, it was the quality he described as poetic which drew him to the French painter.

By 1875 Inness was painting at North Conway, New Hampshire. The 1875 *Approaching Storm* (pl. 23*a*), now owned by the Fort Worth Art Association, is one of those American subjects in which Inness fused European precedent with native theme. About this time, too, he must have painted *Autumn Oaks, ca.* 1875 (frontispiece), in which the formal classical style of his "middle" period is ameliorated by the first traces of the subtle cultural interpenetration of patronage and expression. In general the taste of the patron was bound to influence the artist both in his choice of subject and in the style in which he painted. This relation of forces has not been sufficiently studied for a clear picture to emerge. However, in studying another nineteenth century American painter, E. L. Henry, for convenience I used the catch phrase "visual sentimental image" to describe the characteristic esthetic aims of the time. With Inness, the lure of sentiment was less immediate, but present, nonetheless. His brushstroke became softer, his outlines more fluid, his forms less architectural. This was an evolution not unlike that of Corot, who cut his artistic cloth to please his patrons, abandoning his

early plasticity for atmosphere and luminosity as middle-class patrons demanded more and more sweetness and light. The large canvas of this year, *Evening at Medfield,* unfortunately not available for exhibition, represents an esthetic middle ground, between the Italian manner and the emerging broader, less plastic mode which came to control Inness' painting style. Again, as in *The Monk* or *The Sacred Wood,* his naturalism transcended itself, providing a fantastic vision not typical of his rather placid art outlook. The impetus of his years in Italy continued, culminating in the splendidly formal *Pine Grove, Barberini Villa, Albano, 1876,* not included in the exhibition or monograph. In the same period he painted one of his few genre attempts, *The Rigour of the Game: Kearsarge Hall, North Conway, N. H., ca.* 1875 (pl. 25), which foreshadows his interest in figure painting, to become more evident in the early 1880's. At the same time, the lovely *Approaching Storm* of 1875 (pl. 23a) suggests that Inness' deepest roots were in his own soil.

These years brought Inness success after a long period of insecurity. About 1875, Thomas B. Clarke became interested in Inness' work and began to buy it. Later he acted as Inness' agent. In the 1899 Clarke sale, 35 Innesses were catalogued — a considerable number from one artist. Clarke's patronage brought Inness other patrons — as Inness acknowledged in a letter to the *New York Herald* in 1889 when he wrote that he was greatly indebted to Clarke for "his persistent efforts to find purchasers" for his paintings. Among these collectors were George I. Seney, who presented *Autumn Oaks* to the Metropolitan Museum of Art in 1887; Benjamin Altman, Richard H. Halsted, William H. Fuller, all of New York; and James W. Ellsworth and Potter Palmer of Chicago. Up to this time, Inness' economic history had been one of continuous struggle and pressure. From 1854 on, he had to assume the responsibility of a growing family, and the Innesses had six children in all. Thus he was forced to face the question which has confronted American artists like a chronic disease: "What do

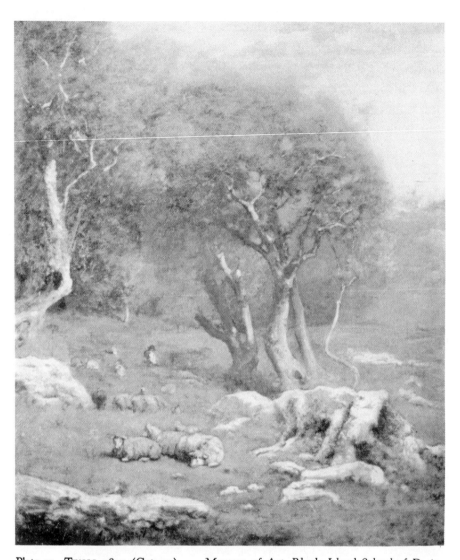

Plate 21 TIVOLI, 1871 (Cat. 22) *Museum of Art, Rhode Island School of Design*

artists live on?" He sought to solve the problem by changing dealers and places of abode. Williams & Everett of Boston succeeded his first "angel," Ogden Haggerty. Later, Doll & Richards took over. Yet before Clarke became his benefactor, Inness had, according to an article by Montgomery Schuyler in the *Forum* in 1894, sold to many American collectors of the period, includ-

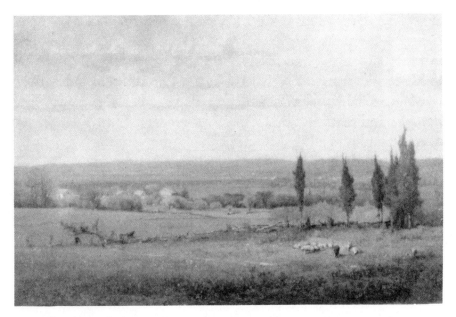

Plate 22 NEAR EAGLESWOOD, N. J., 1869 (Cat. 21) *Macbeth Gallery*

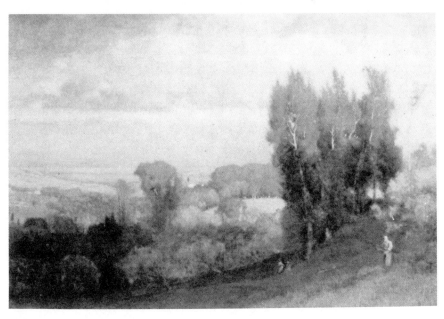

Plate 23 THE OLIVES, 1873 (Cat. 23) *The Toledo Museum of Art*

ing Simeon Draper, Henry Ward Beecher, George Ward Nicholls, George M. Vanderlip, Fletcher Harper, Jr., J. Abner Harper, and Inness' fellow-artist and friend, Samuel Colman. Before he went to Medfield, through Williams & Everett, he had sold to Harrison E. Maynard, Edward Maynard, and Thomas Wigglesworth, all of Boston. So he had not been entirely without patrons. Was it the sporadic and scattered character of nineteenth century patronage which created an especial insecurity?

During the Civil War his work did not sell too well — not unnaturally, since the country was ravaged by war, and war profiteers had not yet been transformed into the *nouveau riche* art patrons which they would ostentatiously become in the seventies and eighties. An economic motive was, in fact, responsible for the long Italian sojourn of the early seventies; for it was believed that foreign subjects would sell better than American. The financial arrangements Inness had made did not work out; in 1873 he wrote his wife (in one of those rare letters quoted in "Life") of their urgent need of cash. As early as 1855, chronic financial worry was revealed when he had to write Mrs. Inness from Scranton, where he had gone to paint *The Lackawanna Valley* (pl. 5), for ten dollars. Many of the stories of his intransigence with buyers may be traced to his resentment at the false position into which the artist is forced when he has to haggle like a peddler for a fair price for his work. The status of commodity, which the work of art assumed in the nineteenth century as a result of the artist's shift from traditional social relations of patronage to the role of free-lance worker in industrial society, is evidenced in these stories. In Rome a New York banker asked the price of two paintings, which were $5000 each. Then he inquired the price of a smaller canvas and was told $2000. Would Inness take $10,000 for the three? Needing money as usual, Inness would — not without a silent protest. However, before the deal was completed by exchange of commodity and cash, Inness learned that his patron had complained the price was too high. The sale was never made.

The biographers quote many such anecdotes, with the buyers all bargaining away like Yankee horse traders. Perhaps the art mart of the Age of Pericles was also based on haggling; but the nearer distance of the nineteenth century makes the performance less appetizing to observe. Inness himself notes, as reported in the "Life," that there is a definite correlation between the amount of cash an artist might hope to obtain from his work and the label attached to the commodity. He is quoted as saying: "Nothing was good without a foreign name on it. Why, when one of our biggest dealers on Fifth Avenue, was asked to procure for a gentleman two American pictures for one thousand dollars each, he said he could not take the order because there was not a picture produced in America worth one thousand dollars. Why? Because they can go to Europe, buy a picture for twenty-five or fifty francs, with a foreign name on it, and sell it at a large profit."

When Inness was fifty, the tide turned. First Clarke took him up. A little later, Roswell Smith, founder of the *Century Magazine,* bought a large canvas for $5000. The Inness fortunes became brighter. At the zenith of his career, Inness had an income of $20,000 or more a year, according to George Inness, Jr. Improved material circumstances allowed Inness at last to root himself in Montclair, where the family had gone toward the end of the 1870's, first renting a cottage on Grove Street and then buying the Dodge mansion, which became the Inness home thereafter. About this time revolt was stirring the American art world. The National Academy of Design, founded in 1825 to improve exhibition, sales and educational opportunities for American artists, had run through its cycle of growth and begun to crystallize into a tyrannical hierarchy, much as political parties do. The reactionary esthetic tendency of the Academy's ruling clique had gone so far that in print academicians called Delacroix "a mere botch," Corot "slovenly," and Millet "coarse and vulgar." Protest against the domination of the Academy by its tired old men led to the formation in 1877 of the Society of American Artists, a group to

Plate 23a THE APPROACHING STORM, 1875 (Cat. 23a)

Plate 24 RAINBOW OVER PERUGIA, 1875 (Cat. 24)

Museum of Fine Arts, Boston

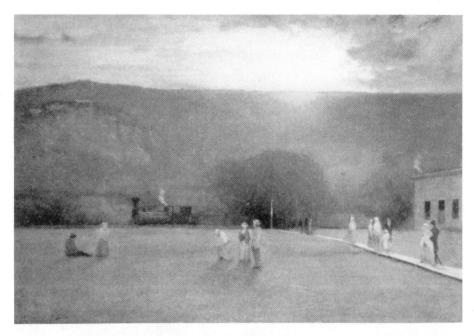

Plate 25 THE RIGOUR OF THE GAME, *ca.* 1875 (Cat. 26) *M. Knoedler & Co.*

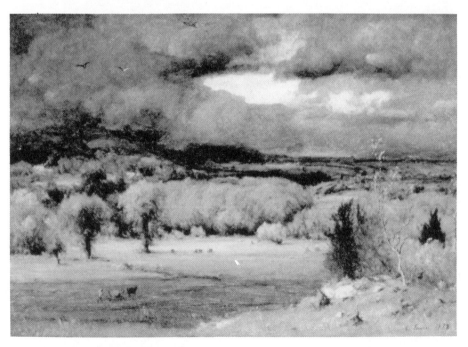

Plate 26 THE COMING STORM, 1878 (Cat. 27) *Albright Art Gallery*

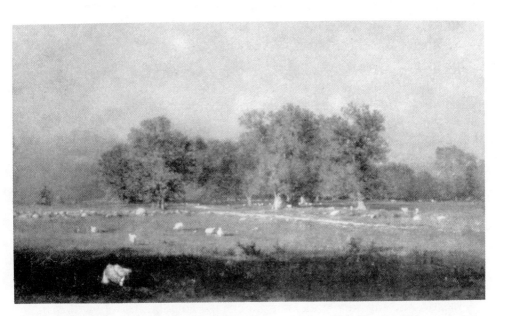

Plate 27 DURHAM, CONNECTICUT, 1878 (Cat. 28) *The Cleveland Museum of Art*

which Inness was elected and with which he exhibited. But he also continued to exhibit with the Academy. If he seems not to have been stirred by storms of art world events, perhaps his personal storms were sufficient. He continued to paint, producing those beautiful canvases of 1878 and 1880, *The Coming Storm* (pl. 26), *Durham, Connecticut* (pl. 27), and *The Coming Storm* (pl. 29). In these his moderate and restrained poetry of nature is mingled with the last vestiges of his personal classicism, to make a new and individual vision of the American landscape.

An adequate income and a home made a more ample life possible for the Innesses. The painter made a trip to England in the early eighties. Mrs. Inness went to Nova Scotia for a summer's vacation while he painted at Milton on the Hudson, staying on the estate of Mrs. Asia Hallock, where during the eighties artists and writers gathered, among them Harriet Beecher Stowe. He also went to Nantucket, for at least two summers, 1879 and 1883. Few canvases of this period have been located. The one exhibited, *A Lighthouse Off Nantucket*, 1879 (pl. 28), helps place him

that year, and two letters written from Siasconset in 1883 give another date. Possibly *A Windy Day*, 1883 (cat. 34), was also painted at Nantucket (p. 80). It has a quality not unlike some of Eastman Johnson's paintings executed there. Of Inness' figure paintings, Daingerfield wrote in 1917: "It is not generally known that he was deeply interested in figure painting, nor that he essayed many nude figures. The problem of light upon flesh interested him greatly, and he made many studies from the model, but always, I believe, destroyed the results." In a period when collectors pined after roseate sunsets and pearly dawns, figure painting was not held in great esteem. Many of these canvases dropped out of sight; and it has been rather difficult to locate first-rate examples of the figure as figure. In *Short Cut, Watchung Station, N. J.*, 1883 (pl. 34) and *A Windy Day*, the figure is a plastic but subsidiary element. Perhaps this exhibition will bring to light other examples.

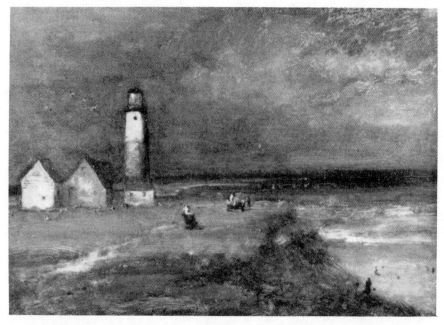

Plate 28 A LIGHTHOUSE OFF NANTUCKET, 1879 (Cat. 29) *Mrs. Edward P. Alker*

Plate 29 THE COMING STORM, ca. 1880 (Cat. 30)

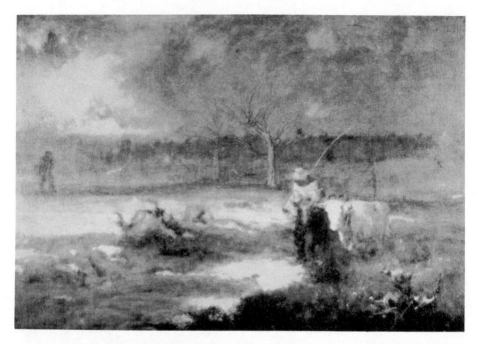

Plate 30 HOMEWARD, 1881 (Cat. 31) *The Brooklyn Museum*

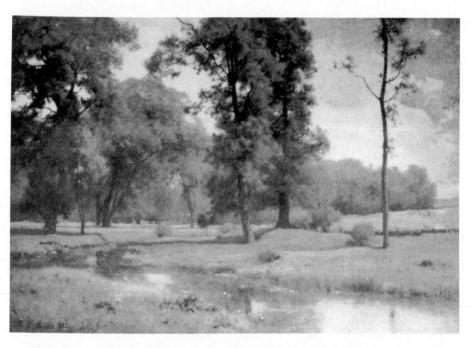

Plate 31 JUNE, 1882 (Cat. 32) *The Brooklyn Museum*

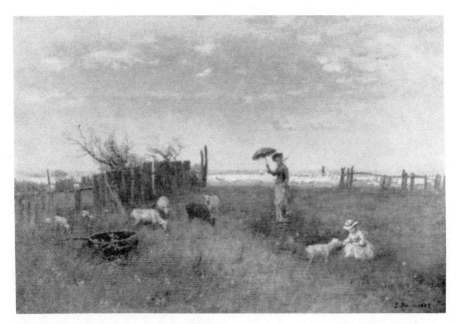

Plate 32 A WINDY DAY, 1883 (Cat. 34) *Mrs. David Bonner*

The last decade of Inness' life, like the last period of his paint-
ing, was suffused by a peaceful half-light. In 1884 he visited
Goochland, Va., probably as a result of his correspondence with
Ripley Hitchcock. In 1889 he visited Chicago and was regally
entertained at the famed Palmer House. In 1891 he went to Cali-
fornia, and paintings of this time survive. Toward the end of
his life, he spent considerable time in Florida, also documented
in a number of canvases. The works of Inness' last years have
served to set the pattern of the popular idea of his art. He is
thought of entirely by the impressionist, crepuscular middle tones
of paintings which swim in a half-light. He himself repudiated
the theories of impressionism, as may be read in a letter quoted
in the recent anthology, *Artists on Art*. But his late work itself,
for whatever reasons, belongs in the impressionist line of develop-
ment. It may, indeed, be a remarkable argument for the multiple
origin of species, spontaneously evolving independent of outside
influences. From 1886 — when he painted *Harvest Moon* (pl.

35) — to 1894, the year of his death — when he painted *Indian Summer* (pl. 42) — Inness grew more preoccupied with monotones of nature, swathing his observed world in misty generalities. He had come a long way from the literal reportage of his early twenties and the solid, classical forms of his best Italian work to the mists and crepuscules of his late landscapes. Plasticity had not entirely vanished, as we may note from the 1891 *Clouded Sun* (pl. 41) and *Home of the Heron* (pl. 40); and as we may see in works as far apart as the 1881 *Homeward* (pl. 30) and the 1894 *Preliminary Preparation for a Painting* (pl. 44), the latter purchased by President L. Clark Seelye of Smith College from the artist's studio as an unfinished work to be used to teach art to college students. But, generally, his view of the natural world had taken on broad and diffuse tonalities in a sort of soft focus vision. Independently and even against his own theories, he had anticipated those painters who brought impressionism into the stream of American painting.

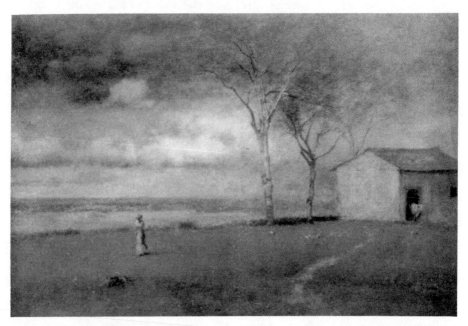

Plate 33 MARCH BREEZES, 1885 (Cat. 35) *M. Knoedler & Co.*

Going to Scotland in 1894 for his health, Inness died at the Bridge-of-Allan on August 3. On August 23, despite short notice and the summer season, an imposing public funeral was held at the National Academy of Design, with its vice-president presiding in the absence of President Thomas Waterman Wood, then in Europe. Tributes paid Inness' memory testify to the distance he had traveled in esteem. "He towered as a giant," one read; and another, "He leaves a significant void," all this uttered with "no desire to unduly exalt the dead." To pay honor to this "pioneer in the tardy development of American landscape painting," his fellow artists journeyed many miles to the services, recorded at length in the New York Times the following day. The obituary read in part: "The ceremony at the Academy of Design was simpler than any impression which its relation may convey. Inness disdained glory even more than money. He had obtained glory more solid, more durable and more universal than many great men of his time. But he never courted it or made the slightest sacrifices in its favor . . . Pompousness did not illuminate his life and would not have fitted his obsequies." Pomp and glory, nevertheless, are to be noted in the Times' account: "The casket of silver and velvet was covered with palm leaves and wreaths of white roses, ivy and lilies of the valley. The ribbons were violet. On a pedestal the fine bronze bust of Inness by Hartley stood at the foot of the casket, and its eyes had a life-like glance. The paintings shone in their usual places on the wall, in all their gaiety. Only the balustrade at the stairs was draped in black. The flag was flying at half mast." Today the obituary style of the American press is less florid; but discounting rhetoric, we judge from this description that by the time of his death Inness had attained considerable prestige. His long, upstream struggle for security and recognition presents a case history, perhaps aggravated by personal eccentricity but typical nonetheless.

His battles of principle with his patrons have been referred to. His way of working has also been recorded by his biographers.

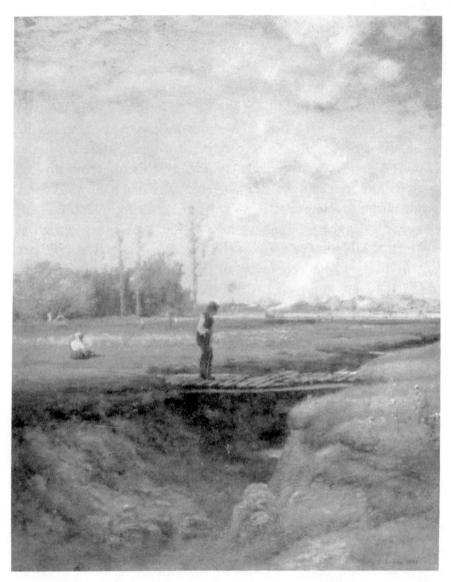

Plate 34 A SHORT CUT, WATCHUNG STATION, N. J., 1883 (Cat. 33)
Philadelphia Museum of Art

Today there are fine Innesses which have been painted over other works. Inness would take a still wet canvas, even one he had just sold, and paint over it in a frenzy of excitement. He sometimes painted a half dozen or more pictures on one canvas, a fact

which makes difficult technical examination by X-ray, ultra-violet, infra-red, and pigment analysis. There are many anecdotes of outraged collectors who found their paintings totally altered by the time they came into their hands. Occasionally the artist would be amenable to reason and wipe out the latest layer, leaving the "underpainting" intact. But if he had painted on a wet canvas, then all was lost — at least to the buyer who wanted the picture he had seen, not the new one painted by Inness between afternoon and the next morning. This habit did not ameliorate his reputation for eccentricity, which developed early in life, Jarves referring to it in 1864. Inness' extravagant behavior was obviously related to his furious tempo of work. He is said to have worked twelve or fifteen hours at the easel, a considerable stint by any standard. If he acted and painted frenetically, frenzy must have been a safety valve, for a less frenetic art than his is hard to imagine.

The esteem and acclaim he had won by the time of his death was built on sustained, hard endeavor, founded as much as anything on a long exhibition record. His early exhibits at the National Academy and the American Art Union have been set down in detail at the beginning of this essay. For the record, again: he showed with the Academy from 1844 to 1894, with the exception of 1851, 1854, 1861, 1864, 1866, 1872, 1876, 1880, 1881, 1884, 1887, 1890 and 1891. His works were exhibited posthumously at the Academy in 1895, while there was a memorial exhibition in 1894 at the Fine Arts Building. He showed at the Pennsylvania Academy of Fine Arts in 1852, 1855, 1868, 1879, 1888, 1892, 1893 and 1894; in the Society of American Artists' second annual in 1879, and also in 1881 and 1882. He exhibited abroad — in the Royal Academy annual exhibitions of 1859, 1863 and 1872; in the Paris Universal Expositions of 1867, 1889 and 1891; at Munich in 1883 and 1892; and in the 1887 American exhibition held in London. There was a special exhibition of his work at the American Art Gallery in New York in 1884; and he had

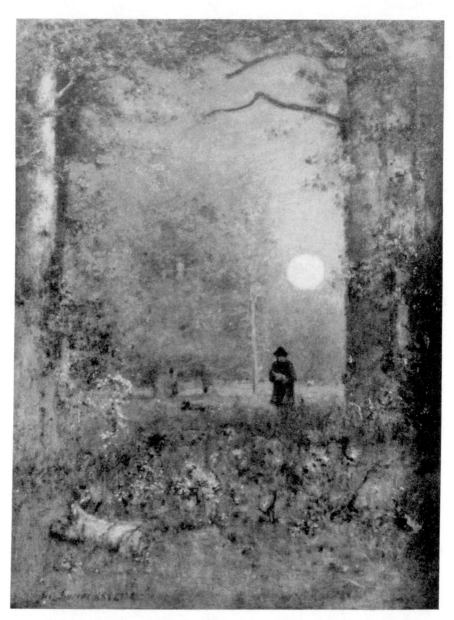

Plate 35 HARVEST MOON, 1886 (Cat. 36) *Dr. George G. Heye*

sent work to the Interstate Industrial Exposition in Chicago,
1877; to the Boston Art Club, 1879; and to the World's Indus-
trial and Cotton Centennial Exposition at New Orleans in 1884'

85. In 1888 he was represented in the first annual exhibition of American oil paintings at the Art Institute of Chicago, and thereafter in 1889 and 1894. In 1893 he had been included in the World's Columbian Exposition at Chicago.

Examples of his painting were shown posthumously in the first annual of the Carnegie Institute in 1896; at the opening exhibition of the Brooklyn Museum in 1897; at the Union League Club of New York in 1898 with paintings by Winslow Homer; in the Society of American Artists' 21st annual in 1899; at the Buffalo Pan-American Exposition of 1901; at the South Carolina Interstate West Indian Exposition of 1901-02; at the 1904 St. Louis Universal Exposition; at the inaugural exhibition of the Albright Art Gallery in Buffalo in 1905; at the 1905 Lewis and Clark Centennial Exposition in Portland, Ore.; and in a one-man show in Nashville the same year. It became the fashion almost for Innesses to be included in opening exhibitions of museums, the John Herron Art Institute coming next, this in 1906, for its inaugural exhibition. In 1909, Inness was included in the Alaska-Yukon-Pacific Exposition; and in 1910 his work was shown in Berlin and Munich. Meanwhile his "mortal residue" had been exhibited and sold in the 1895 executors' sale, in the 1899 Clarke sale, and again in 1904. He came before the public dramatically in 1911 when the Innesses owned by Emerson McMillin were bought by Knoedler for $100,000 and soon sold to Edward B. Butler of Chicago by the Reinhardt Galleries for $150,000. These comprise the Butler Collection of the Art Institute, which includes some of the finest Innesses, although unfortunately the terms of the gift do not permit these to be lent. The story of Inness' return to fame in the past twenty years since the 1925 centennial exhibitions at the Albright Art Gallery and the Macbeth Gallery has been set down briefly above and may be followed in tabular form in the Chronology and the Bibliography.

Honors and awards are curiously few: A. N. A., 1853; N. A., 1868; second medal, Munich, *Königlicher Glaspalast, VI Inter-*

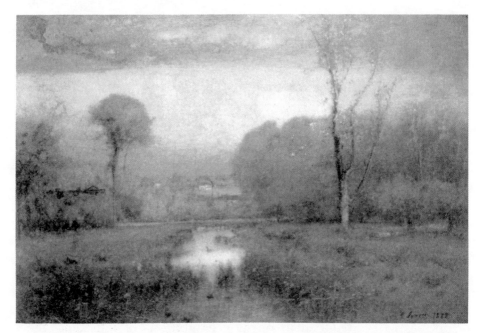

Plate 36 AUTUMN GOLD, 1888 (Cat. 37) Wadsworth Atheneum

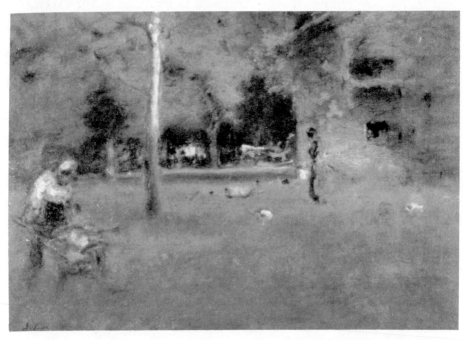

Plate 37 THE OLD BARN, *ca.* 1888 (Cat. 38) *The Misses Rose, Rachel and Helen Hartley*

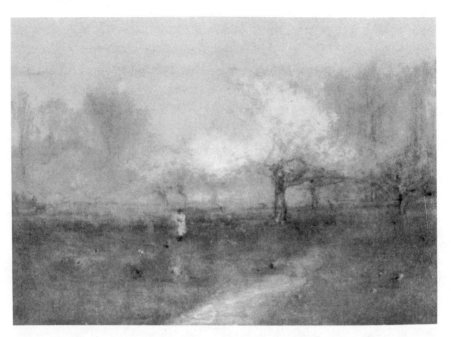

Plate 38 SPRING BLOSSOMS, 1889 (Cat. 39) *The Metropolitan Museum of Art*

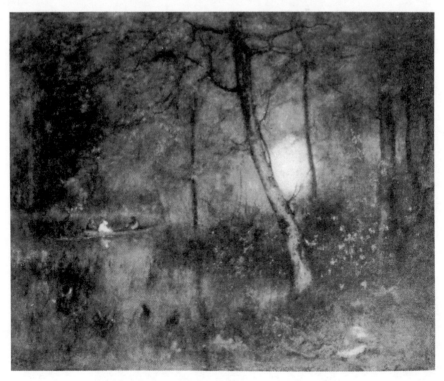

Plate 39 A POOL IN THE WOODS, 1892 (Cat. 42) *Worcester Art Museum*

nationale Kunst Ausstellung, 1892; bronze medal, Paris, *Exposition Universelle,* 1900. His success may be read rather in the graph of rising prices which mark the end of his life and in the representation his work found in major art institutions, both during his lifetime and after. Writing of the 1899 Clarke sale, a contemporary critic records the fact that the "lost" *Gray Lowery Day* of 1877, for which Clarke had paid about $300, had been sold to Henry Sampson for $10,150, an increase in market value of 33 times. In 1913 the Inness 1894 *Tenafly: Autumn,* a canvas 31 by 46, went for $16,500 in the Emerson McMillin sale — a new record for an American painting at that time. The previous "high" had also been for an Inness. At the same time, a Corot sold for $75,200, so that the traditional disproportion between native and foreign work persisted. In this sale, the 1894 *Indian Summer* (pl. 42) sold for $9000 to Knoedler's. In 1924 it was reported to have brought $30,000. The rising market for Inness is frequently found reported in the art press, the *American Art News* in 1918 tracing the history of a canvas which Clarke had bought from the artist in 1891 for $2000, a prevailing price of the time. This sold for $5600 from the 1899 Clarke sale to George A. Hearn. When it came on the auction block in 1918, the opening bid for it was $25,000 and it was bought by Scott & Fowles for a record price of $30,000. Finally in 1922, *Spirit of Autumn* brought $60,000. So, though medals were few, Inness was vindicated when the prices of his paintings rose to such high figures.

Inness' fluctuations in critical esteem show even more inconsistencies than the graph of his economic status or of his esthetic evolution. His slowness to establish a reputation, contrasted with the extraordinary vogue for his painting toward the end of his life and after, can best be explained in relation to the art fashions of the period. From the beginning he was outside the conventional stream of American painting. When he began to paint, landscape itself was a recent departure, the commemorative function of the portrait having occupied painters till the advent of

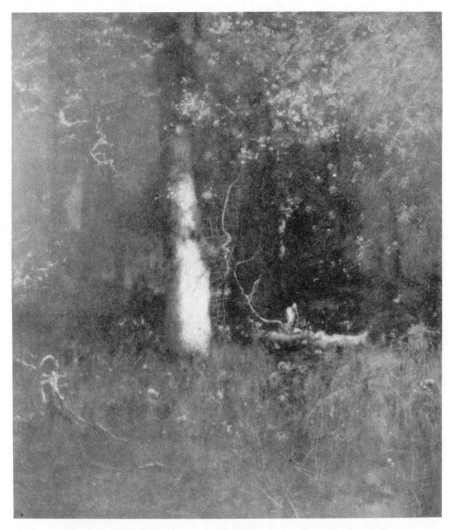

Plate 40 THE HOME OF THE HERON, 1891 (Cat. 41)
Museum of Historic Art, Princeton University

photography brought about a technological unemployment of
face painters and limners. In 1851 the *American Art Union
Bulletin* felt it necessary to comment on the fact that in the cur-
rent National Academy exhibition 175 out of 416 items were
landscapes and only 150 portraits. When landscape had become
accepted as a respectable category of artistic activity, it was still

within the confines of the Hudson River School and of the roman-
tic movement. Inness' highly personal expression did not reassure
the beholder with a sense of the familiar and sentimental, hence
Bierstadt's two-million-dollar estate, and Inness' more modest
$100,000. Isham commented on Inness' early lack of a following,
writing: "Inness had less popular vogue than most of the men
around him. Until the end of his life his larger pictures sold
with difficulty, and the newspapers served him with no such
adulation as they gave to Church or Bierstadt." Why the others
were fashionable and Inness not may be understood by referring
to the description of the Inness funeral. It was a period of osten-
tation and display, elaborate not to say vulgar. Artists had "Turk-
ish corners" in their studios, draped with dust-catchers; and when
they gave parties, they rented palms twenty feet high. Their
patrons luxuriated in a gold-plated rococo indigenous to and
unique in the United States. Inness' spirit certainly was not osten-
tatious. If he shunned the view and the panorama, he also shunned
display. There are many stories which tell of how, even when
he had a good income, he loved to wear old clothes, neat and
clean to be sure, but poverty-stricken in appearance. His stub-
born insistence that the artist still owned his painting even after
he had sold it certainly did not endear him to customers who
bought pictures on a par with champagne and fast trotters. His
lack of vogue is not strange, therefore.

On the other hand, from the beginning he had critical notice.
Newspaper comments reprinted in the American Art Union pub-
lications speak well of the young artist's work — this when he
was not yet twenty-five. Jarves early appreciated Inness' expres-
sion, despite its unevenness and contradictions. By the time Tucker-
man wrote "American Artist Life" in 1867, Inness was an accepted
American master, though this art historian seems to have erred
in describing him as singularly loyal to his French ideal. If the
painter's own witness be believed, he took almost nothing from
French painting, though of the Barbizon School he thought Rous-

seau, Daubigny and Corot the best, and Constable and Turner also won his praise. According to Montgomery Schuyler, it was Delacroix, however, who commanded his greatest admiration. The emotional sympathy is based on real similarities between the French romanticist and Inness. That there was a stylistic influence, though, does not seem apparent. By 1890 Inness had won a foreign audience. The French portrait painter, Benjamin Constant, seeing Inness' paintings in New York, arranged for a Paris dealer to handle them. The Bibliography shows that Inness received considerable publicity, even early in his life.

The most extravagant and lengthy encomiums were printed after his death. Constant himself contributed a glowing piece to the *New York Times*. The *New York Evening Post* of January 5, 1895, published a curiously fresh criticism, writing: "He had the mind of a romanticist, keen in its artistic perceptions, and very susceptible to emotional impression, but capricious, headlong, impulsive, prone to extravagance and given to chimerical theories. It lacked in repose and it lacked in tenacity. Seeking for truth, it too often ran hopelessly to error, through pursuit of fancy and lack of definite aim. Perhaps some of his failure to realize fully his ideal was due to a faulty hand. He never received a thorough technical training. His was not a nature that could or would submit to any working out of a formula but his own, and so he soon abandoned masters. He was not, however, a provincial or illeducated painter, by any means. The art of the world was better known to him than to many Parisians. He traveled much and knew the methods of others quite well . . . Not even Rousseau and the Fontainebleau painters could make him pay the compliment of imitation, or assimilation. He followed no one." George Inness, Jr., considered these statements uncomplimentary, according to "Life." Today they suggest that the writer had uncommon good sense; for he goes on to say: "There has been so much extravagant talk about Inness since his death that it seems necessary for some one to point out his limitations, but we would not

Plate 41 THE CLOUDED SUN, 1891 (Cat. 40)

Plate 42 INDIAN SUMMER, 1894 (Cat. 43) Col. Albert E. Peirce

be understood as saying he was all limitations. On the contrary
. . . no landscape-painter in the history of American art holds
higher rank. With more mental balance and a surer technic he
would have been the greatest landscape-painter of any time or
people. His limitations denied him that rank, but still left him
among the great ones."

Another critic who evaluated Inness judiciously was Mont-
gomery Schuyler. His essay in the November, 1894, *Forum* shows
that American art criticism has a tradition to be rediscovered,
even as American art has. In the main, Inness had a good press.
Charles H. Caffin carried on the evaluation in the early twen-
tieth century. By this time (1907) extravagant tributes had had
a decade in which to subside. Caffin, one of the most interesting
of native critics, no doubt would have been outside the rhetorical
orbit any way. He wrote, in part, in his "Story of American
Painting," as follows: "George Inness was a pathfinder whose orig-
inality and fiery zeal for nature blazed a new trail that has led
on to the present notable expansion of American landscape-paint-
ing . . . He learned, first of all, that principle of synthesis, of
selection and arrangement . . . that the best art does not consist
in representing everything in sight, but in discovering what are
the salient and essential characteristics, and in setting these down
in a masterly summary. He learned, in effect, the value of omit-
ting details so as to secure additional force for the ensemble; . . .
He learned, in the second place, a new motive: no longer to look
for 'views' in nature, but to study fragments of it intimately; to
render portraits of nature, in which the local facts should be of
importance, not as facts, but as vehicles of expression. It was a
mood of nature, or a mood aroused in himself, that he strove to
embody; and, by thus becoming a subjective painter, he cut him-
self off entirely from the objectivity of contemporary landscapes."

This judgment Inness himself should have been in agreement
with. He is quoted as saying that "The true use of art is, first,
to cultivate the artist's own spiritual nature and, second, to enter

as a factor into general civilization." Again, he defined the aim of art as follows: "The purpose of the painter is simply to repro- duce in other minds the impression which a scene has made upon him. A work of art does not appeal to the intellect. It does not appeal to the moral sense. Its aim is not to instruct, not to edify, but to awaken an emotion." In denying functions of content and communication to art, Inness was unselfconsciously mirroring trends of artistic theory which the twentieth century developed into formalistic rationalizations. The concept of self-expression as the prime end of art justifies the artist's rootlessness and lack of function in a culture which esteems art as a commodity. Another interpretation of Inness' words may be made, however. When he speaks of the moral and intellectual, we may read this as referring to the literary confections which adorned the easels of many painters. Surely his distaste for pre-Raphaelitism was not so much a turning away from its highly polished surface as from its lack of contemporary meaning. Was Inness seeking to put forward as a canon the concept that art is basically created out of tangible, visible, sensuous materials of experience and that it must be understood in material terms before it can be appre- hended in the esthetic complex? By such an interpretation he becomes peculiarly modern, and perhaps it is such an overtone in his expression which is most satisfying and significant today.

Spanning the Jacksonian and post-Civil War eras, Inness lived two lives. His youth and early painting years were spent in the golden day of American nationalism. The libertarian, agrarian ideals of the Revolution and of Jefferson had not yielded place to the crescent industrialism which became the ruling energy of American life after the Civil War. In the eye of the historian, Frederick Jackson Turner, the "frontier" was not yet a dream; it was a reality of territorial expansion controlling the destinies of national growth, until free soil and slave soil became symbols of two economic orders at war. Land could still be the theme of an artist's or a poet's wonder; and it was so for Inness,

[65]

as it was for a whole group of American painters. The White Mountains, the Hudson River, the Rockies, lured our artists, as the vast expanses beyond the Cumberland Gap lured explorers and settlers. America was truly a wilderness, a virgin land, substantially untouched by its aboriginal inhabitants. This was land no foot had invaded, land where the frontiersman's axe had never fallen, land where wealth of the earth lay waiting. It was not bathed in the blood of old wars or burdened with memory of the centuries. A man might stand up and look off to the horizon, shouting "This is my land, my own!" He could be proud and free, because no tyrannous past interposed chains of remembrance between him and the object of his love. Weary, worn, ravaged, scarred with the marching feet of time, the European land was not new, wild, virginal, as the American land was. A particular tenderness or a particular ambition or even a particular lust informed our explorers and settlers and artists: theirs to seize the new land and possess it.

This may be read in the eagerness with which American painters scoured the continent. Audubon was but one of many, though perhaps the most indefatigable, to traverse mountains, rivers, flat lands. As America's rivers poured new population into the interior, so they floated Bingham and Chester Harding and many another artist down their currents. The land was not an abstraction for American artists. It was a physical, tangible, valuable thing. Where European painting made landscape a background, land was the arena of American action before the Civil War. Even after the decisions of the Civil War set the nation on the path of industrialism, land remained a major economic factor in American growth. Though Turner's theory of the frontier has been subjected to revision, it remains a convenient hypothesis for explaining much of our development. From the beginning of colonial days, cities stood in the wilderness; nevertheless something went out of American life when the last free land was gone, when the silver spike was driven into the Union Pacific, when

the land grant college era ended. A time of hopefulness came to an end, a time of struggle and question began.

This is the double world in which Inness lived and worked. In his subjective way he expresses this duality. Before the Civil War, nature and the land still beckoned. Opportunity was the keynote of life in America. A man might go west and grow up with the country. He could hew trees down, raise a cabin for his family, cultivate newly cleared acres. Nature was the real and compelling experience for most Americans of the age; the west-ward movement brought them close to nature in a relation as immediate and practical as the daily quest for bread. After the Civil War, veterans went west, aided by the homestead act, and painters and photographers journeyed with the U. S. Geologic Survey expeditions to chart the western lands. But somehow the horizon closed down. Great fortunes began to rise, and great factories to tower over the American countryside. Forces of accel-erating technology were at work — vertical transit with the inven-tion of the Otis passenger elevator in the early 1850's; Bessemer steel and vastly multiplied tensile strength of metals; long shad-ows cast by steel frame construction; concentration of population in cities; rationale of mass production.

Where was nature? Left to the artists, ravished from the hands of farmers and turned over to rentiers, despoiled by slums and fab-ulous land rents, scarred by needless soil erosion of reckless forestry and agriculture! The continent was one, knit by the railroads; but the railroads poured their soot into the cities, took over curving and beautiful riversides because river grades were ready-made, preëmpted 99-year franchises, built their lobby in Washington. Did nature have a lobby there, or the artists? The old smiling face of nature was distorted. In an age of innocence, the philos-opher could eye nature romantically, as did most of the Hudson River painters, or he could scan it objectively, depicting every minute crevice, cranny, stratum of rock, leaf, berry, twig. He could be emotional or unemotional, as temperament dictated.

After the Civil War, the sensitive artist had little option; generally he would be estranged by the unceasing rape of the land. Only a synthetic version of nature would be palatable to those responsible for the devastation; for the reality was not pretty and not romantic. No tradition in American life had prepared the way for an objectivity like that advanced by the early twentieth century "Ash Can" school or for a realism like that of the later documentary movement.

Inness was no more a victim of the American duality than any other artist of his time; but he was a victim. The serenity of his early landscapes — *The Lackawanna Valley* and *Hackensack Meadows,* to name two — gave way to a more consciously placid mood. Whereas in the pre-Civil War work he was serene almost as if innately, in the post-Civil War work he struggled for serenity. In an effort to solve the dilemma, he was led more and more toward a deliberately optimistic mood, but optimism was paid for by a loss of substance. From *Hackensack Meadows, Passing Shower, Landscape, Leeds in the Catskills, Harvest Scene,* which speak of specific themes with specific emotion, he withdrew into generalities. His subjects of the late eighties and early nineties can be located on the map, but they have no definite character of "place"; they could as well be anywhere. Why had place names become abhorrent to the artist? Was it the specificity of what had happened to the American land that made specific references now unacceptable to him?

Inness' swing to impressionist generalizations of landscape may be due in part to other factors than distaste for the native scene. Seeking a significance he did not find in a mutilated physical world, he perhaps sought a compensatory meaning in the private world of his own imagination. If the external view was repugnant, what had the soul to offer? This was not a retreat from life, any more than Emily Dickinson's barricading of herself behind the Amherst rhododendrons was a retreat. It was a measure necessary for survival and self-preservation. In this respect, the duality of

American life left a curious pattern of flight upon nineteenth century culture, worthy of longer study.

How may Inness' evolution be read? What qualities characterize his undoubtedly major contribution to American painting? How is he to be measured in relation to the main criteria of his time? First, we may note his independence and indeed defiance of his sources. Second, and more significant, his intimate and close sense of his own acre of America should be remembered in comparison with those contemporaries of his who cut a wider artistic swath. He has given us a visual record of that measurable area he chose for his own — New Jersey meadows, Medfield, Delaware Water Gap, Hudson River, scenes from his Montclair studio — which have besides the individual poetry of his own nature an almost documentary character. We are so accustomed to thinking of his crepuscule that his earlier subject matter is sometimes overlooked; yet it is not an uncommon thing to have lay spectators look at an Inness and identify the place from their own familiarity with it. Thus his fragments of nature come to life in a kind of personal realism. Essentially he remained true to his own way of seeing and was not tempted by fields outside the boundaries he had set for himself. If landscape had displaced portraiture in American painting at this time, genre painting was also on the wane. Inness apparently had no pull in this direction. His own insecurity, material and emotional, would not have drawn him to joyful and exuberant zest in scenes of daily life, such as Mount reveled in. *Rigour of the Game* has no abandon; it is as genteel as the art patrons of the time, who may have played croquet politely when they were not visiting artists' studios. But within the world he had staked out for himself, Inness was at home and at ease. He saw the seasons come and go, and mild succession of equinoxes and solstices was reflected in a changing palette, not as dramatic as his admired Delacroix's, not as falsely scientific as the hated impressionists', but cool, calm and moderate, the empirical vision of an artist who had only his unaided eye to rely on.

At this point Inness parts company with the going tradition of nineteenth century American painting, naturalism. For most of our painters, naturalism was as rigid a convention as classicism. For Inness, a style based on a pragmatic relation between nature and the painter took on an individual aspect. His naturalism was modified by his character and became, like his choice of subjects, modest and moderate in expression. These qualities may be noted in color, angle of view, the subordination of figures and buildings within the total landscape scheme, the very character of his brush-stroke. Rejecting the grandiose for the intimate, he magnified the scale of the homely and familiar till his best paintings became a portrait of the average man's aspiration for peace, plenty and calm after the storms of life. These attributes themselves would not suffice to make Inness' art important or lasting. The ultimate qual-ity of his work which makes it timely for our time is sincerity. Eschewing the spectacle and the panorama, he found in the daily ebb and flow of nature a sustaining and vital life. Those closed-in valleys were the common home and amphitheater of American life, those low-lying foothills did not shut off the sky nor scale its heights, those delicately stylized clusters of trees were not storm-tossed or tragic, those unobtrusive figures crossing a field were not Homeric heroes declaiming an American romantic alex-andrine. Rather this was the world Inness saw day in and day out, and the world his fellow men saw as they went about their day's work. His legato tempo recalls the slow powerful heartbeat, unhurried and unstressed. That Inness created his moderate epic amid personal stress and strain is a paradox for which art may be thankful. In a larger sense, we may be thankful, too, that amid the esthetic temptations of his period, he resisted the enticements of flamboyance for the integrity of the fragment, for from these fragments, and all the fragments of human experience and obser-vation, honestly felt and honestly recorded, we now begin to reconstruct the world of our immediate American past.

CATALOG

Works in the exhibition are listed chronologically. Unless otherwise stated, they are oil on canvas. Measurements are given in inches, height first. All oils in the exhibition are reproduced in the monograph. To eliminate mechanical bibliographical apparatus, references under individual catalog entries have been simplified, the full reference being listed in the Bibliography. References to titles of exhibitions have also been condensed, as the full title is listed in the Chronology. Where plate and catalog numbers differ both are given.

CATALOG

1 SURVEYING, 14¾ x 19¾; lower right: G. I. 1846
Inness exhibited at the American Art Union and the National Academy of Design in 1846. Probably this is one of those early works. Part of an old torn label on the frame reads: "R. T. [?] Fraser/ Picture Framemaker/ (at the American Art Union)/ . . . Broadway"
LENT BY M. KNOEDLER & CO., NEW YORK

2 LANDSCAPE, 30 x 45; lower right: G. Inness 1848
Presented to the California Palace of the Legion of Honor by H. K. S. Williams of New York in 1942. Inness exhibited at the National Academy of Design and the American Art Union in 1848. No doubt this is one of those paintings, though no title listed fits the painting. Formerly in the collections of Mrs. Jonathan Scott Hartley, George Ainslie, August Heckscher.
LENT BY THE CALIFORNIA PALACE OF THE
LEGION OF HONOR, SAN FRANCISCO

3 THE OLD MILL, 30 x 42; lower right: G. Inness 1849
Exhibited at the Art Institute of Chicago and the Whitney Museum of American Art, 1945, as *Our Old Mill.* Recorded in "The Hudson River School," pp. 104, 105, 121. In 1849 Inness exhibited at the American Art Union a painting entitled *The Old Mill,* No. 128. The painting was "distributed" to James P. Kelly of New York by lottery No. 5891. Formerly in the collection of Mr. and Mrs. William Owen Goodman. LENT BY THE ART INSTITUTE OF CHICAGO

4 SUMMER, 30 x 25; lower left: G. Inness 1850
Purchased by the Museum of the Cranbrook Academy of Art in 1943.
LENT BY THE MUSEUM OF THE CRANBROOK ACADEMY
OF ART, BLOOMFIELD HILLS, MICHIGAN

5 THE LACKAWANNA VALLEY, 33 7/8 x 50 3/16; lower left: G. Inness [1855]
Recorded in "Life," 1917, pp. 108-111; Hartley sale catalog, No. 76, as *The First Roundhouse of the D. L. and W. R. R. at Scranton.* Presented to the National Gallery of Art by Mrs. Huttleston Rogers in 1945. LENT BY THE NATIONAL GALLERY OF ART, WASHINGTON, D. C.

[73]

5a LAKE COMO (?), 40⅜ x 54⅜; lower right: monogram: GI 1857

The history of this painting is not complete. However, when considered in relation to other examples of this period, the subject, the style, and the signature would seem to indicate that it is a work by Inness. Records show that Inness had dealings, prior to the Civil War, with an art dealer whose stamp appears on the back of the canvas — Williams, Stevens, Williams & Co., 353 Broadway, New York. The painting was purchased by a New Haven collector fifty or more years ago. Formerly in the collections of Nicholas W. Hubinger, Lillian R. Hubinger, Jane Hubinger Pabst.

LENT BY YALE UNIVERSITY ART GALLERY, NEW HAVEN

6 MARINE, 18 x 24 (oval); lower right: G. I. 1857

LENT BY THE MACBETH GALLERY, NEW YORK

7 COAST SCENE, 22⅛ x 30¼ [ca. 1857]

Bequeathed to the Metropolitan Museum of Art by Eliza W. Howland in 1917. LENT BY THE METROPOLITAN MUSEUM OF ART

8 ITALIAN LANDSCAPE, 20 x 30; lower right: G. Inness 1858

LENT ANONYMOUSLY

9 HACKENSACK MEADOWS, SUNSET, 17 x 25; lower left: G. Inness 1859

Recorded as No. 22 in the Stuart Collection catalog, New York Public Library. Purchased from the artist in 1859 by Robert L. Stuart.

LENT BY THE NEW-YORK HISTORICAL SOCIETY, NEW YORK

10 LANDSCAPE (DELAWARE WATER GAP), 32 x 52; lower right: monogram in red: G I [1859]

Recorded in the *Montclair Art Museum Bulletin,* May, 1931. Presented to the Montclair Art Museum by Mrs. F. G. H. Fayen in memory of her husband, in 1931.

LENT BY THE MONTCLAIR ART MUSEUM, MONTCLAIR, NEW JERSEY

10a VIEW ON THE DELAWARE, colored lithograph, colored part 14¾ x 22⅜ [1860]

Currier & Ives issued this print in 1860, after the 1859 oil, *Landscape (Delaware Water Gap).* It is one of the few known examples of graphic use of Inness' work.

LENT BY HARRY SHAW NEWMAN, THE OLD PRINT SHOP, NEW YORK

11 CLEARING UP, 15¼ x 25⅜; lower left: G. Inness 1860
Purchased from the artist by George Walter Vincent Smith on April
13, 1861. Recorded and reproduced in "American Romantic Paint-
ing," p. 38, pl. 185.
OWNED BY THE GEORGE WALTER VINCENT SMITH ART MUSEUM

11a LANDSCAPE (pl. 43), 8 x 10; lower right: G. Inness
Purchased from the artist by George Walter Vincent Smith on April
13, 1861.
OWNED BY THE GEORGE WALTER VINCENT SMITH ART MUSEUM

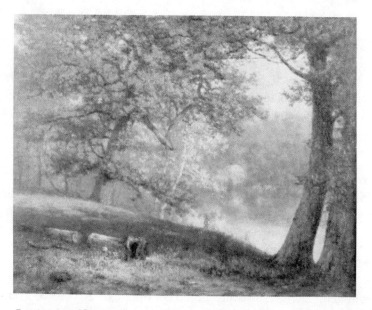

Plate 43 LANDSCAPE (Cat. 11a) *The George Walter Vincent Smith Art Museum*

12 PASSING SHOWER, 26 x 40; lower left: G. Inness 1860
Exhibited, Macbeth Gallery, 1925; Whitney Museum of American
Art, 1938; Springfield Museum of Fine Arts, 1938; Carnegie Insti-
tute, 1939; Century Association, New York, 1940. Recorded in "A
Century of American Landscape Painting," 1938; Carnegie Institute
catalog, 1939. LENT BY BARTLETT ARKELL

13 ON THE DELAWARE RIVER, 28¼ x 48¼ [*ca.* 1861]
Exhibited San Francisco, Golden Gate Exposition, 1940. Recorded
in *Brooklyn Institute of Arts and Sciences Bulletin,* 1913; catalog,

[75]

Golden Gate Exposition, 1940, p. 127. Formerly in the collections of Christopher Meyer, Mrs. Catherine L. (Meyer) Lowther, Frederick W. Kost. Presented to the Brooklyn Museum in 1913 by members of the Brooklyn Institute of Arts and Sciences.

LENT BY THE BROOKLYN MUSEUM

14 SHADES OF EVENING, $15\frac{1}{4}$ x $26\frac{1}{4}$; lower right: G. Inness 1863
George Walter Vincent Smith purchased the painting from the artist. Exhibited: Whitney Museum of American Art, 1938; Springfield Museum of Fine Arts, 1938. Recorded in "A Century of American Landscape Painting," 1938.

OWNED BY THE GEORGE WALTER VINCENT SMITH ART MUSEUM

14a NEWBURG GIDNEY, pencil drawing, $10\frac{1}{2}$ x $16\frac{1}{2}$; paper; right of center: Geo. Inness. (not illustrated)
George Walter Vincent Smith received it from the artist. It is a sketch for the painting, No. 14, *Shades of Evening*. On the back it bears the following pencilled notation, "Mountains higher and the middle ground more foreshortened."

OWNED BY THE GEORGE WALTER VINCENT SMITH ART MUSEUM

15 LANDSCAPE, 30 x 48; lower left: Geo. Inness 1864
The grandfather of the present owner purchased this painting directly from the artist. LENT BY HARRY T. PETERS, COURTESY OF THE
HARRY SHAW NEWMAN GALLERY, NEW YORK

16 LEEDS IN THE CATSKILLS, $47\frac{1}{2}$ x $71\frac{3}{4}$; lower right: G. Inness [1865]
Exhibited, Detroit Institute of Arts, 1944-45. Recorded, *American Art News,* November 9, 1918, p. 1 under the title, "Mountain Landscape — The Painter at Work"; *Art News,* June 12, 1937, p. 11; "World of the Romantic Artist," p. 29; "American Romantic Painting," p. 38, pl. 181. Formerly in the collection of Thomas E. H. Curtis. Presented to the Berkshire Museum by Zenas Crane in 1920.

LENT BY THE BERKSHIRE MUSEUM, PITTSFIELD, MASSACHUSETTS

17 CHRISTMAS EVE, 22 x 30; lower left: G. Inness 1866
Exhibited, Brooks Memorial Art Gallery, Memphis, Tenn., 1945. Inness' dentist, a Dr. Hill, is said to have received the painting in payment of his bill. It was formerly in the collection of Horatio S. Rubens of New York. LENT BY M. KNOEDLER & CO., NEW YORK

18 HUDSON RIVER VALLEY, 24 x 34; lower right: G. Inness 1867
Exhibited, Anderson Galleries, December, 1922. Recorded and repro-
duced in *Detroit Institute of Arts Bulletin*, March, 1924. Presented
to the Detroit Museum by the Detroit Museum of Art Founders
Society in 1924.
The Bulletin's account reads: "The picture has an unusual history for
an early American canvas. It was bought for the Jacob Schiff collec-
tion, and was in the Stadel Museum, in Germany at Frankfort-on-the-
Main. That museum planned to build up a representative collection
of American paintings. As time passed, however, this dream did not
materialize. Detroit was thus able to secure their Inness."
LENT BY THE DETROIT INSTITUTE OF ARTS, DETROIT, MICHIGAN

19 HARVEST SCENE IN THE DELAWARE VALLEY, 30⅛ x 44¾;
lower left: G. Inness 1867
Recorded in the Walker Art Galleries catalog, 1927, p. 85; Index of
Twentieth Century Artists, v. 4, 1936; reproduced in *Brush and
Pencil*, November, 1901, p. 75, and October, 1906, p. 146.
LENT BY THE WALKER ART CENTER, MINNEAPOLIS, MINNESOTA

20 LAKE ALBANO, ITALY, 30 x 45; lower left: Geo. Inness 1869
Exhibited, Museum of Modern Art, 1932. Recorded in "American
Painting and Sculpture," 1932, p. 32; Duncan Phillips, "A Collection
in the Making," [c] 1926, p. 100; "Art in America," 1934, p. 71.
LENT BY THE PHILLIPS MEMORIAL GALLERY, WASHINGTON, D. C.

21 NEAR EAGLESWOOD, N. J. (pl. 22), 16 x 25; lower right:
G. Inness 1869 LENT BY THE MACBETH GALLERY, NEW YORK

22 TIVOLI (pl. 21), 25 x 21; lower left: G. Inness 1871
Presented to the Rhode Island School of Design by Jesse Metcalf in
1895. LENT BY MUSEUM OF ART, RHODE ISLAND SCHOOL
OF DESIGN, PROVIDENCE, RHODE ISLAND

23 THE OLIVES, 20 x 30; lower right: Inness February 1873
Exhibited, Carnegie Institute, 1939. Recorded, "Century of American
Landscape Painting, 1800-1900," p. 35, no. 76. Formerly in the collec-
tions of H. E. and Edward D. Maynard, Henry E. Dalley. Presented
to the Toledo Museum of Art by J. D. Robinson in memory of Mary
Elizabeth Robinson.
LENT BY THE TOLEDO MUSEUM OF ART, TOLEDO, OHIO

23a THE APPROACHING STORM, 19 11/16 x 28 5/16; lower right:
G. Inness, 1875
Purchased in 1904 by the Fort Worth Art Association, by public
subscription, from Messrs. Williams & Everett of Boston. Recorded
in the catalog of the Fort Worth Museum of Art permanent collec-
tion, 1928. Said to be a scene at North Conway, N. H.
LENT BY THE FORT WORTH ART ASSOCIATION, FORT WORTH, TEXAS

24 RAINBOW OVER PERUGIA, 38½ x 63½; lower right:
G. Inness 1875
Exhibited, M. H. de Young Memorial Museum, San Francisco, 1935.
Recorded, catalog of exhibition of American painting, M. H. de
Young Memorial Museum, 1935; catalog, Museum of Fine Arts, 1921,
pp. 211-212. Presented to the Museum of Fine Arts, Boston, by
James Brown Case in 1920.
LENT BY THE MUSEUM OF FINE ARTS, BOSTON, MASSACHUSETTS

25 AUTUMN OAKS (frontispiece), 21⅛ x 30¼; lower right:
G. Inness [ca. 1875]
Exhibited, Berlin and Munich, 1910; National Academy of Design,
1939. Recorded in catalog of the exhibition of American art, Berlin,
p. 62; catalog of paintings, Metropolitan Museum of Art, 1931, p.
177; *House and Garden,* October, 1937 (color reproduction); *Book-of-
the-Month Club News,* October, 1944 (color reproduction). George
I. Seney, a Brooklyn collector who was a patron of Inness, presented
the painting to the Metropolitan Museum of Art in 1887.
LENT BY THE METROPOLITAN MUSEUM OF ART, NEW YORK

26 THE RIGOUR OF THE GAME: KEARSARGE HALL, NORTH
CONWAY, NEW HAMPSHIRE (pl. 25), 20 x 30½; lower left:
G. Inness [ca. 1875]
Exhibited in "Sports in American Art," Museum of Fine Arts, Bos-
ton, 1944, as *Croquet, Conway, N. H.* Recorded in American Art
Association sale catalog, January 15, 1937, as *The Rigour of the
Game,* No. 42, from the collection of Cornelius E. Donnellon.
LENT BY KNOEDLER & CO., NEW YORK

27 THE COMING STORM (pl. 26), 26 x 39; lower right:
G. Inness 1878
Exhibited, Museum of Modern Art, 1932; Whitney Museum of
American Art, 1938; Springfield Museum of Fine Arts, 1938; Car-

negie Institute, 1939; New York World's Fair, 1940. Recorded in catalog of the Albright Art Gallery, 1919, p. 23; "Art in America," 1934, p. 72; and in the catalogs of the above exhibitions. Formerly in the collections of Mrs. William Bryan, Mrs. George Lewis. Purchased by the Albright Art Gallery with income from the Albert Hallery Tracy Fund.

LENT BY THE ALBRIGHT ART GALLERY, BUFFALO, NEW YORK

28 DURHAM, CONNECTICUT (pl. 27), 15½ x 26½; lower right: G. Inness [1878]
Exhibited, Cleveland Museum of Art, 1937. Recorded in E. McMillin sale catalog, 1913; "American Painting from 1860 Till Today," p. 28. Presented to the Cleveland Museum of Art by Charles W. Harkness in 1927.

LENT BY THE CLEVELAND MUSEUM OF ART, CLEVELAND, OHIO

29 A LIGHTHOUSE OFF NANTUCKET (pl. 28), 18 x 26; lower left: G. Inness 1879
Recorded, Executors' Sale, 1895, No. 15; "Masters in Art," 1908, p. 41; "Fifty Paintings," 1913, No. 11.

LENT BY MRS. EDWARD P. ALKER, GREAT NECK, LONG ISLAND, N. Y.

30 THE COMING STORM (pl. 29), 27½ x 42¼; lower center: G. Inness [ca. 1880]
Exhibited, Museum of Modern Art, 1943-1944, as The Approaching Storm. Recorded in Hartley sale catalog, 1927, No. 74; Handbook, Addison Gallery of American Art, 1939, p. 22; Life, June 15, 1942, p. 59 (color reproduction); "Romantic Painting in America," 1943, pp. 75, 136-137. Inness' wedding present to his daughter, Mrs. Jonathan Scott Hartley, this painting was sold in the 1927 Hartley sale for $6500. LENT BY THE ADDISON GALLERY OF AMERICAN ART,
PHILLIPS ACADEMY, ANDOVER, MASSACHUSETTS

31 HOMEWARD (pl. 30), 20¼ x 30¼; lower right: G. Inness 1881
Recorded in the Brooklyn Museum Quarterly, April, 1937. Bequest of Michael Friedsam to the Brooklyn Museum.

LENT BY THE BROOKLYN MUSEUM

32 JUNE (pl. 31), 30 x 45; lower left: G. Inness 1882
Exhibited, Macbeth Gallery, 1925. Bequest of Mrs. William A. Putnam to the Brooklyn Museum. LENT BY THE BROOKLYN MUSEUM

33 SHORT CUT, WATCHUNG STATION, N. J. (pl. 34), 37¾ x 29;
lower right: G. Inness 1883
Recorded in "Masters of Art," 1908, p. 41; "Index of Twentieth
Century Artists," December, 1936. This painting received a bronze
medal at the 1889 Paris Exposition.
LENT BY THE PHILADELPHIA MUSEUM OF ART,
PHILADELPHIA, PENNSYLVANIA

34 A WINDY DAY (pl. 32), 20 x 30, oil on wood panel;
lower right: G. Inness 1883
Recorded in "Fifty Paintings," 1913, No. 18. An old American Art
Association label, from No. 6 East 23rd Street, on the back of the
panel gives the title of this painting as "Morning Walk, Sconsett"
confirming the conjecture on page 46 that this was painted on Inness'
second trip to Nantucket. The label also states that the price of the
painting is $800.
LENT BY MRS. DAVID BONNER, GREAT NECK, LONG ISLAND, N. Y.

35 MARCH BREEZES, W. VA. (pl. 33), 20 x 30; [1885]
Exhibited, Macbeth Gallery, 1925. Formerly in the collections of
James G. Shepherd and Charles B. Squier.
LENT BY M. KNOEDLER & CO., NEW YORK

36 HARVEST MOON (pl. 35), 39 x 29½; lower left: G. Inness 1886
LENT BY DR. GEORGE G. HEYE, NEW YORK

37 AUTUMN GOLD (pl. 36), 30 x 45; lower right: G. Inness 1888
Formerly in the collection of John R. Waters. Purchased by the
Wadsworth Atheneum from the Keney Fund in 1897.
LENT BY THE WADSWORTH ATHENEUM, HARTFORD, CONNECTICUT

38 THE OLD BARN (pl. 37), 30 x 45; lower left: G. Inness
[ca. 1888]
Exhibited, Inness 110th anniversary exhibition, Montclair Art Mu-
seum, 1935. Recorded in Hartley sale catalog, 1927, No. 78.
LENT BY THE MISSES ROSE, RACHEL AND HELEN HARTLEY,
SOUTHAMPTON, LONG ISLAND, N. Y., THROUGH THE
COURTESY OF THE MONTCLAIR ART MUSEUM

39 SPRING BLOSSOMS (pl. 38), 30¼ x 45¾; left center:
Geo. Inness 1889
Recorded in the catalog of the Hearn collection, 1908, p. 166; catalog,
Metropolitan Museum of Art, 1926, p. 168. Presented to the Metro-

politan Museum of Art by George A. Hearn in memory of Arthur Hoppock Hearn in 1911.

40 THE CLOUDED SUN (pl. 41), 30 x 45; lower right:
G. Inness 1891
Exhibited, M. H. de Young Memorial Museum, San Francisco, 1935; Whitney Museum of American Art, 1938; Springfield Museum of Fine Arts, 1938; Carnegie Institute, 1939. Recorded in the catalogs of the above exhibitions. Purchased by the Carnegie Institute from the Clarke sale in 1899 for $6100.

41 THE HOME OF THE HERON (pl. 40), $42\frac{1}{8}$ x 37; lower left:
G. Inness 1891
Exhibited, Macbeth Gallery, 1925; Whitney Museum of American Art, 1938; Springfield Museum of Fine Arts, 1938; Carnegie Institute, 1939. Recorded, *Art News,* August-September, 1943, p. 9, as well as in catalogs of above. Presented by Mrs. Victor Harris to the Museum of Historic Art, Princeton University.

42 A POOL IN THE WOODS (pl. 39), 22 x 27; lower right:
G. Inness 1892
Exhibited, Inness centennial exhibition, Albright Art Gallery, 1925. Recorded in Worcester Art Museum Bulletin, 1913, v. 4, no. 1, p. 4; Worcester Art Museum Catalog, 1922, p. 122; catalog of the centennial exhibition, 1925, p. 11. Formerly in the collection of Burton Mansfield.

43 INDIAN SUMMER (pl. 42), $30\frac{1}{4}$ x $41\frac{3}{4}$; lower right:
G. Inness 1894
Exhibited, M. Knoedler & Co., 1920; Carnegie Institute, 1940; M. Knoedler & Co., 1943. Recorded, "Survey of American Paintings," 1940, no. 149. Purchased by the Central Congregational Church of Chicago and given to Dr. Newell Dwight Hillis.

44 PRELIMINARY PREPARATION FOR A PAINTING, 30 x 45½;
lower left: G. Inness 1894 (also called "On the Edge of the
Wood")

According to Alfred Vance Churchill, former director of the Smith
College Museum of Art, this unfinished canvas was purchased from
Inness' studio by the first president of Smith College, L. Clark Seelye.
Given funds to develop a study art collection, President Seelye made
a practice of visiting artists' studios and buying directly from leading
artists of that time. He had chosen a finished canvas when he saw
the present painting and had the idea of having an unfinished work for
the students to study. Inness signed and dated the canvas on the spot.

LENT BY THE SMITH COLLEGE MUSEUM OF ART,

NORTHAMPTON, MASSACHUSETTS

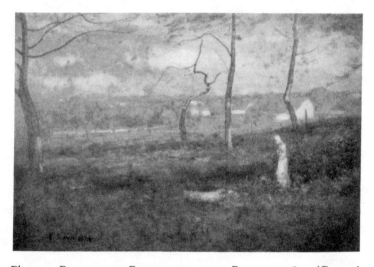

Plate 44 PRELIMINARY PREPARATION FOR A PAINTING, 1894 (Cat. 44)
Smith College Museum of Art

CHRONOLOGY

1825 George Inness born near Newburgh, N. Y. Family soon moves to New York

1830 Inness family moves to farm near Newark, N. J., where George is educated

1841 Inness apprenticed to Sherman & Smith, New York map engravers
His first recorded painting, The Mill, dates about this time

1844 Exhibits in National Academy of Design

1846 Studies a month with Régis Gignoux, a pupil of Delaroche

1847 Makes first trip abroad, to England and Italy

1850 Marries second wife, Elizabeth Hart, and goes abroad again

1853 Elected associate member of the Academy

1854 Visits Paris

1855 Paints The Lackawanna Valley

1859 Goes to Medfield, Mass., and lives there five years

1865 Paints Peace and Plenty, and goes to Eagleswood, N. J., to live

1867 Removes to Brooklyn

1868 Elected N. A.

1870 To Italy and France for four years, and on return to Boston

1875 Living in New York, and Thomas B. Clarke begins to buy his work

1878 To Montclair to live and work

1879 Visits Chicago

1891 Visits Yosemite and California

1894 Dies at the Bridge-of-Allan, Scotland, August 3
Public funeral at the National Academy of Design, August 23
Memorial exhibition in the Fine Arts Building, New York

1895 Executors' sale totals $108,000

1899 Inness prices rise in Thomas B. Clarke sale

1911 Emerson McMillin's Innesses sold for $100,000, and sold in turn to Edward
B. Butler of Chicago for $150,000

1913 Inness' Tenafly: Autumn brings $16,500 in McMillin sale — new "High" for
an American painting

1918 Another Inness sets a record — $30,000

1922 Spirit of Autumn brings $60,000

1925 Centenary of Inness' birth celebrated by Albright Art Gallery and Macbeth
Gallery

1929 (ca.) "The Rediscovery of America" begins

1935 Montclair Art Museum's 110th Inness anniversary exhibition

1946 To date, Rediscovery of America continues, Inness included

BIBLIOGRAPHY

Entries have been listed in this bibliography to chart the growth of Inness' vogue during his life and after. In the interests of simplicity and chronological sequence, some standard dictionaries have been omitted, as well as other useful references. Nineteenth century material, particularly periodicals, have been listed more fully to document Inness' press early in his career. Exhibition catalogs of the past fifteen years show how Inness' return to popularity fits into the general rediscovery of America in this period.

1849 American Art Union. Bulletin, April
 Literary World. September 1
 American Art Union. Bulletin, October
 Evening Mirror. December 3
1850 American Art Union. Bulletin, April 16
1864 Jarves, James Jackson. The Art-Idea. New York
1867 Harper's Weekly. July 13
 Tuckerman, Henry T. Book of the Artists. New York
1873 Atlantic Monthly. January. "Art: Inness and His Pictures"
1876 Art Journal. March. "American Painters — George Inness"
1878 Harper's Monthly. February. "A Painter on Painting"
1879 Sheldon, G. W. American Painters. New York
1880 Benjamin, S. G. W. Art in America. New York
1881 Benjamin, S. G. W. Our American Artists for Young People. Boston
1882 Eckford, Henry. "George Inness." Century. May
1884 American Art Gallery. Special Exhibition of Oil Paintings, Works of
 Mr. George Inness, N. A. New York
1886 Champlin, J. D., and Perkins, C. C. Cyclopaedia of Painters and Paintings.
 New York
1888 Appleton's Cyclopaedia. New York (and in later editions)
 Cook, Clarence. Art and Artists of Our Time. New York
 Sheldon, G. W. Recent Ideals of American Art. New York
1889 Montgomery, Walter, ed. American Art and American Art Collections.
 Boston
1893 Fraser, W. Lewis. "American Artists Series: George Inness." Century. April
1894 Critic. September 1. "Fine Arts: Art Notes"
 Critic. August 11. "Fine Arts: George Inness"
 Fowler, Frank. "A Master Landscape Painter: The Late George Inness."
 Harper's Weekly. December 29
 Schuyler, Montgomery. "George Inness." Harper's Weekly. August 18
 Schuyler, Montgomery. "George Inness: The Man and His Work." Forum.
 November

1895 Critic. January 5. "Fine Arts: Paintings by the Late George Inness"
 Daingerfield, Elliott. "A Reminiscence of George Inness." Monthly Illustrator.
 March
 Executors' Sale. Catalogue of Paintings by the late George Inness, N. A.
 Chickering Hall, February 12, 13 and 14, 1894. New York
 Literary Digest. June 22. "A Near View of George Inness"
 Muther, Richard. The History of Modern Painting. New York
 Public Opinion. February 28. "Art; Characteristics of George Inness"
 Sheldon, G. W. "Characteristics of George Inness." Century. February
 Trumble, Alfred. George Inness: A Memorial. New York
1896 Downes, W. H., and Robinson, F. T. "Later American Masters."
 New England Magazine. April
1899 Coffin, W. A. [Essay in the catalogue of the Thomas B. Clarke sale]
 Van Dyke, John C. The History of Painting. New York
 Walton, Henry B. "The Art Work of the Late George Inness." Metropolitan
 Magazine. May
1900 Downes, W. H. Twelve Great Artists. Boston
1901 Rummell, John, and Berlin, E. M. Aims and Ideals of Representative American
 Painters, Buffalo
1902 Hartman, S. C. A History of American Art. Boston
 Van Dyke, John. [Essay in Encyclopaedia Britannica Supplement.] Edinburgh
1903 Caffin, Charles H. American Masters of Painting. New York
 Ruge, Clara. "Amerikanische Maler." Kunst und Kunsthandwerk, v. 6,
 p. 390-392
 Van Dyke, John C. "George Inness." Outlook. March 7
 Wiley, E. The Old and New Renaissance. A Group of Studies in Art and
 Letters. Nashville
1905 Isham, Samuel. The History of American Painting. New York
 Sturgis, Russell. The Appreciation of Pictures. New York
1906 Ruge, Clara. "Moderne Amerikanische Maler." Kunst für Alle. March
1907 Caffin, Charles H. The Story of American Painting. New York
 McSpadden, J. Walker. Famous Painters of America. New York
1908 Masters in Art. June. Boston
 Scribner's. October. "The Field of Art: George Inness"
1910 Königliche Akademie der Kunst. Ausstellung Amerikanischer Kunst. Berlin
1911 Art Institute of Chicago. "The Inness Collection." Bulletin. April. Chicago
 Daingerfield, Elliott. George Inness, the Man and His Art. New York.
 Privately printed
 Henry Reinhardt & Son. Exhibition of Eighteen Pictures by the American
 Master of Landscape Painting, the Late George Inness. Chicago
 Hoeber, Arthur. "A Remarkable Collection of Landscapes by the late George
 Inness, N. A." International Studio. April
1913 Daingerfield, Elliott. Fifty Paintings by George Inness. New York. Privately
 printed
1917 Daingerfield, Elliott. A Collection of Paintings by George Inness, N. A.
 New York
 Inness, George, Jr. Life, Art and Letters of George Inness. New York

1919 Van Dyke, John C. American Painting and Its Tradition. New York

1920 Bryant, Lorinda Munson. American Pictures and Their Painters. New York

1922 American Art News. February 4. "$60,000 for Inness' *Spirit of Autumn*"

1923 Cortissoz, Royal. American Artists. New York

1925 Albright Art Gallery. George Inness Centennial Exhibition, 1825-1925. Buffalo
 Cortissoz, Royal. Personalities in Art. New York
 Goodrich, Lloyd. "George Inness and American Landscape Painting." The Arts. February
 Macbeth Gallery. George Inness, 1825-1894: Centennial Exhibition. New York

1926 Gerwig, H. Fifty Famous Painters. New York
 Phillips, Duncan. A Collection in the Making. New York

1927 Abbot, Edith R. The Great Painters. New York
 Mather, Frank Jewett, Jr., et al. The American Spirit in Art. v. 12, The Pageant of America. New Haven
 Works by George Inness: The Collection of Mrs. Jonathan Scott Hartley. American Art Association. New York

1928 Bulliet, C. J. Apples and Madonnas. New York
 A Letter from George Inness to Ripley Hitchcock. New York. Privately printed

1929 La Follette, Suzanne. Art in America. New York

1930 Irwin, Grace. Trail Blazers in American Art. New York
 Newark Museum. Development of American Painting, 1700-1900. Newark, N. J.

1931 Mather, Frank Jewett, Jr. Estimates in Art. New York
 Neuhaus, Eugen. The History and Ideals of American Art. Stanford University, Calif.

1932 Museum of Modern Art. American Painting and Sculpture, 1862-1932. New York

1933 Art Institute of Chicago. Catalogue of a Century of Progress Exhibition of Paintings and Sculpture. Chicago

1934 Cahill, Holger, and Barr, Alfred H., Jr., eds. Art in America. New York
 Hillyer, J. M., and Huey, E. G. A Child's History of Art. New York

1935 Montclair Art Museum. Exhibition of Paintings by George Inness: One Hundred and Tenth Anniversary, 1825-1935. Montclair, N. J.

1936 Cleveland Art Museum. American Painting from 1860 Till Today. Cleveland
 San Francisco Museum of Art. Survey of Landscape Painting. San Francisco
 Virginia Museum of Art. Main Currents in the Development of American Painting. Richmond

1938 Whitney Museum of American Art. A Century of Landscape Painting, 1800-1900. With an essay by Lloyd Goodrich. New York

1939 San Francisco Golden Gate International Exposition. Historical American Paintings. San Francisco
 Carnegie Institute. Century of American Landscape Painting, 1800-1900

1940 Carnegie Institute. A Survey of American Painting. Pittsburgh
Century Association. Fifty Years of American Painting. New York
McCausland, Elizabeth. George Inness and Thomas Eakins. [Living American Art monograph.] New York
New York World's Fair. American and European Paintings. New York

1941 Santa Barbara Museum of Art. Painting Today and Yesterday. Santa Barbara, Calif.

1942 Whitney Museum of American Art. A History of American Watercolor Painting. With an essay by Alan Burroughs. New York

1943 Museum of Modern Art. Romantic Painting in America. New York

1944 Cournos, John. "Half-Forgotten Poet: For George Inness Fifty Years After His Death." Art News. July 1
M. Knoedler & Co. American Painting: Landscape, Genre, and Still Life of the 19th and 20th Century
Macbeth Gallery. American Paintings of the Early 19th Century. New York
Newhouse Galleries. The American Scene, 1820-1870. New York
Richardson, E. P. American Romantic Painting. New York

1945 Goodrich, Lloyd. American Watercolor and Winslow Homer. Minneapolis
Goodrich, Lloyd. Winslow Homer. New York
Sweet, Frederick A. The Hudson River School and the Early American Landscape Tradition. Chicago